VAN LIFE

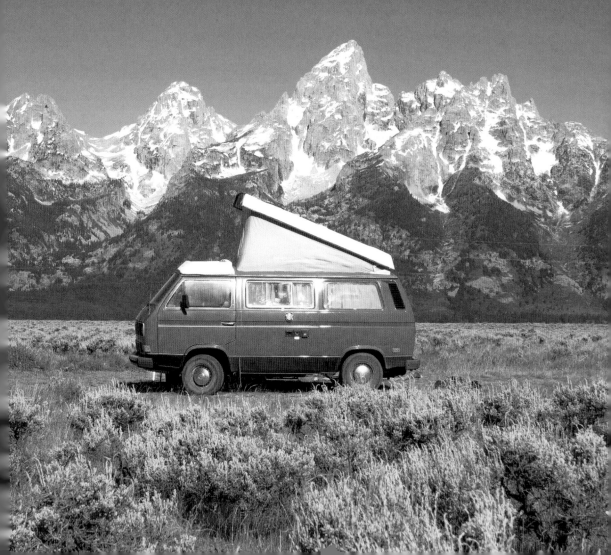

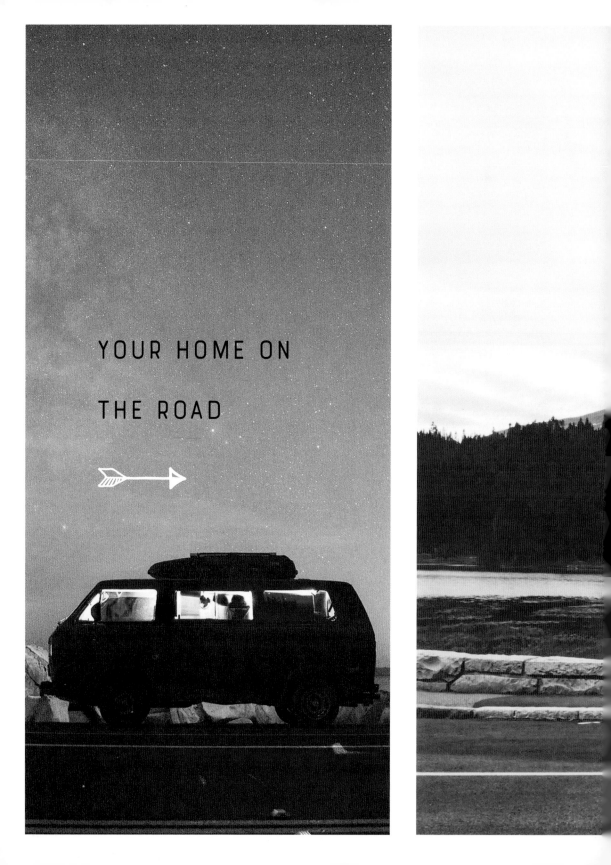

YOUR HOME ON

THE ROAD

VAN LIFE

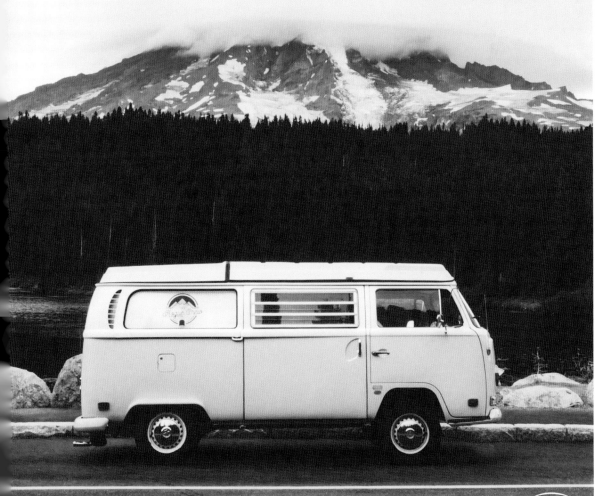

FOSTER HUNTINGTON

sphere

SPHERE

Copyright © 2017 by Foster Huntington

Cover design by Amanda Kain
Photo credit by Road for Greta

Cover copyright © 2017 by Hachette Book Group, Inc.

1 3 5 7 9 10 8 6 4 2

First published in the United States of America in 2017 by Black Dog & Leventhal Publishers
This edition published in 2017 by Sphere

Note that there is a contributor list on page 245 that should be considered an extension of this copyright page.

Print book interior design by Laura Klynstra

A CIP catalogue record for this book is available from the British Library.

ISBN 978-0-7515-7027-4

Printed and bound in Germany by Mohn Media

Papers used by Sphere are from well-managed forests and other responsible sources.

MIX
Paper from
responsible sources
FSC® C104740
www.fsc.org

Sphere
An imprint of
Little, Brown Book Group
Carmelite House
50 Victoria Embankment
London EC4Y 0DZ

An Hachette UK Company
www.hachette.co.uk

www.littlebrown.co.uk

Half title: Volkswagen Westfalia (Cowboy Jackpot), Great Teton, Wyoming; contributed by Christine Gilbert
Previous page, left: 1986 Volkswagen Vanagon, Ventura, California; contributed by Evan Skoczenski
Previous page, right: 1977 Volkswagen Westfalia, Mount Hood, Oregon; contributed by Callie McMullin
Opposite: 1976 Volkswagen Westfalia (Sunshine), Kansas; contributed by J.R. Switchgrass

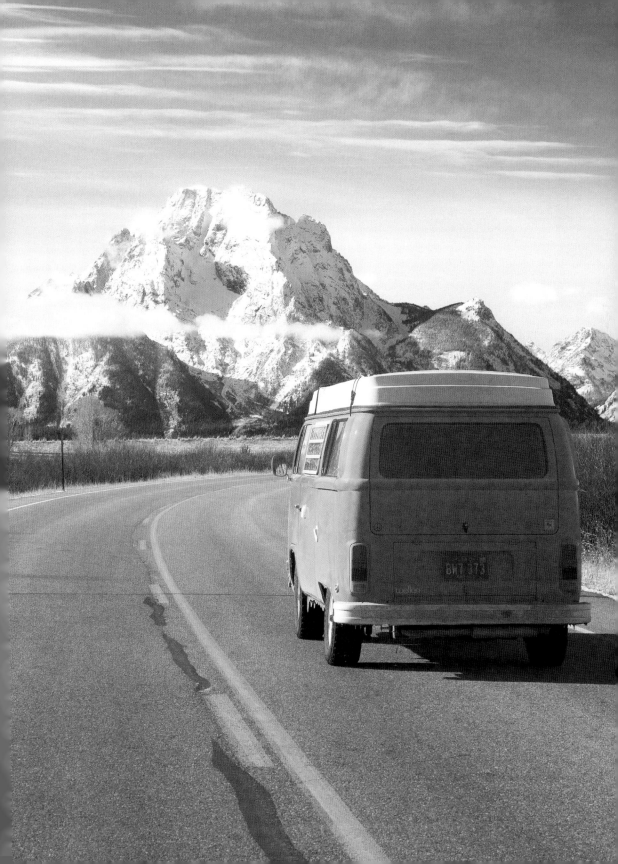

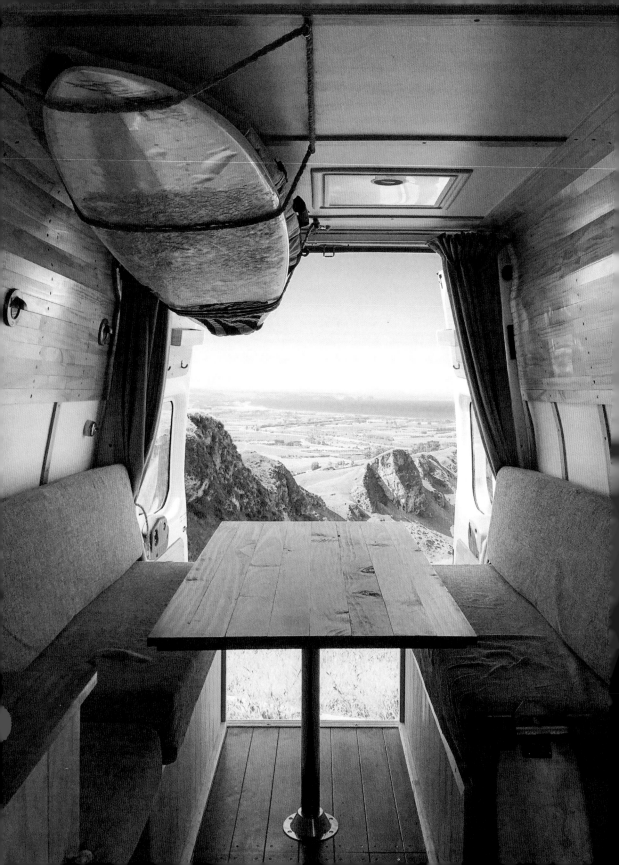

CONTENTS

2008 Ford Transit (Rusty), Hawke's Bay, New Zealand; contributed by Jonathan Edward Johnston

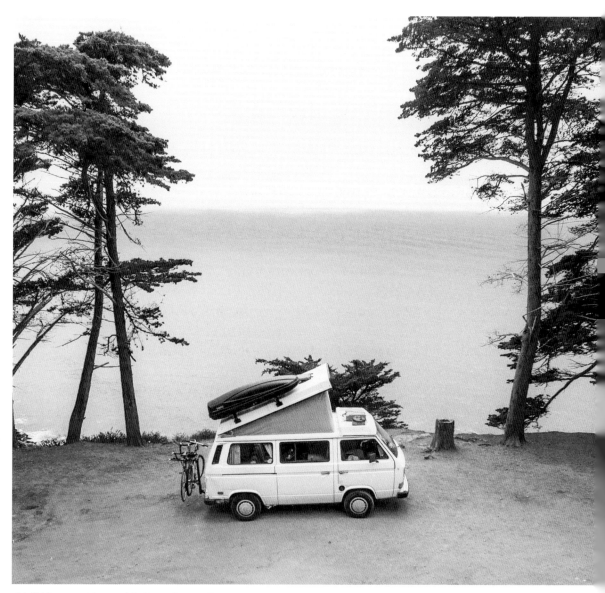

1986 Volkswagen Vanagon Wolfsburg Edition (Penelope the Westy), Big Sur, California; contributed by Gunnar Widowski

I hope the photos, stories, and interviews in this book will plant a seed or inspire a trip, or maybe even a bigger lifestyle change of your own. Mark Twain famously said, "Travel is fatal to prejudice, bigotry, and narrow-mindedness, and many of our people need it sorely on these accounts." I agree with this wholeheartedly. My best times have been behind the wheel of a van, looking for a place to park for the night, eager to wake up with the sunrise, and continue on down the road.

—FOSTER HUNTINGTON

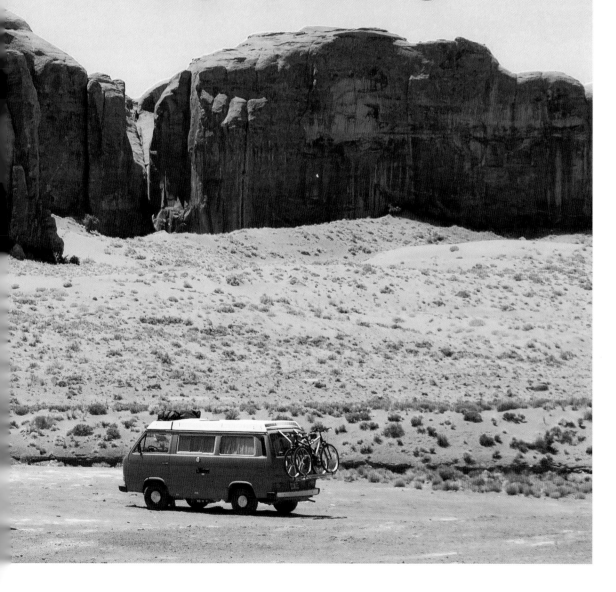

CHAPTER 1
VOLKSWAGEN T3 VANS

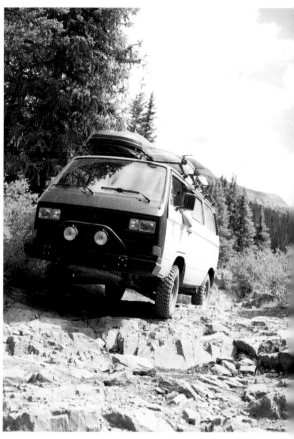

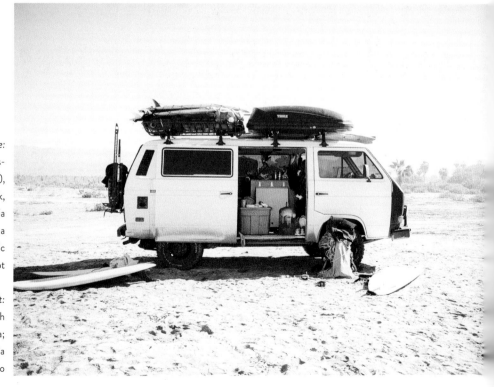

Previous page:
1984 Volkswagen Transporter Westfalia (Popo), Yosemite National Park, California
Contributed by Joanna Boukhabza and Eric Bournot

Clockwise from the left:
Vancouver Island, British Columbia, Canada; Gothic, Colorado; Baja California, Mexico

Escape from New York: How my first van led to two years on the road, eighty thousand miles on the odometer, and a whole new way of living

Popping off the lid of my burrito bowl, I unsheathed the plastic fork and knife from their plastic covering and mixed the layers of beans, rice, and meat with a deft flip of the wrist. Leaning back in my Aeron chair, I took the first bite. It was by no means up to the standards of a West Coast burrito, but it was still virtually unparalleled compared to the other lunch offerings of midtown Manhattan. Chewing with satisfaction, I minimized my work email, opened up a fresh browser window, and went to thesamba.com, a forum and classified listing for Volkswagen vans.

"Check this thing out," I said as I chewed a bite and motioned to a listing for a 1987 VW Vanagon Syncro.

Tyson, my coworker, leaned back from his laptop and burrito bowl to humor my excitement and look at my screen.

"Damn, that's pretty sick. Is that 4x4?" He returned to his daily lunch perusing of sneaker websites.

"Yah, VW made these in the eighties for a few years. I wanna get one," I explained.

"But what would you do with it? Where would you park it?"

This was a logical line of questioning from Tyson, referring to the astronomical cost of having a car in New York City. I had a plan, though, even if it was a simple one.

"I want to travel around in it for a while. They have a bed and little kitchen. I'd just surf. Some backpacking. Probably live in it."

"And say goodbye by to all of this?" Tyson said, motioning to our windowless office.

On the walk to work, on the subway riding around Manhattan, and as I fell asleep, my thoughts were consumed with exploring the never-ending dirt roads of the West.

"Exactly. That's the whole point." I laughed as I shoveled another forkful of burrito into my mouth.

Over the next few weeks, web searches for vans grew from the occasional lunchtime to a full-time obsession as I was checking half a dozen forums daily looking for new listings. After hours of research and reading testimonials, I honed in on what I had to have: the VW T3 Syncro—the rarest of the rare. Roughly three thousand of these vans were imported into the US from 1987 to 1991, and since then the remaining fleet has garnered a cult-like following among both off-road enthusiasts and the VW van hippie community. Syncros, as they are affectionately called, can go anywhere, albeit slowly. They are underpowered, but moving at a slower speed, a more deliberate pace, seemed awfully appealing to me. The fast pace of my corporate surroundings was starting to take its toll and I was getting closer to making a life-changing move.

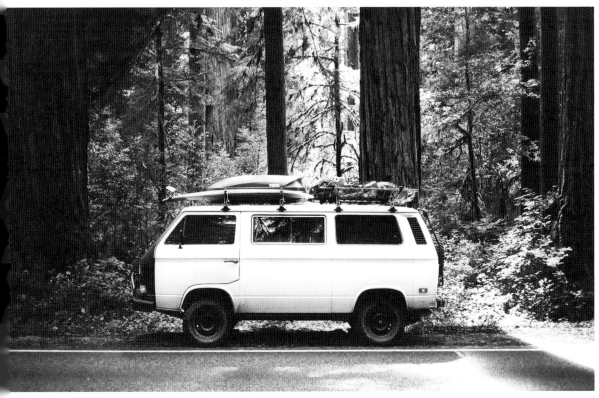

Top: Big Sur, California; *bottom:* Humboldt County, California

This rare and unattainable van was the subject of countless hours of Internet searching, but my daydreaming focused on the places that it could potentially unlock. On the walk to work, on the subway riding around Manhattan, and as I fell asleep, my thoughts were consumed with exploring the never-ending dirt roads of the West and Mexico. I fantasized about exploring remote sections of Baja, sleeping under the redwoods in Northern California, and carving through snowy roads in the mountains of Wyoming. I read other people's accounts of living out of their vans. I talked to friends who had spent time living out of their cars. I watched videos on YouTube. No doubt I was obsessed, and it was all starting to seem so simple, and even attainable. All I needed was a home built on four wheels.

My infatuation with livable vehicles dated back some years prior, to a month-long road trip that I took around California with family in the mid-nineties. After the first couple days on the road, I quickly adapted to riding around in the cab-over bed of the small RV listening to the *Forrest Gump* soundtrack. It was on this trip that I fell in love with the ease and simplicity of just pulling over to the side of the road to sleep and waking up in a beautiful place. On this California road trip, my parents told stories from their past, of exploring Mexico in a three-hundred-dollar van and of epic family tours around northern Wisconsin. All of this fueled my infatuation with this type of self-contained travel. My eight-year-old self equated a vehicle that you could sleep in to a drivable fort or a customized escape capsule. In other words, there was nothing better.

After high school in Oregon I moved to Maine, spending four years at a small college north of Augusta. During this time I explored the vastness of the Pine Tree State with my friend and fellow future van dweller Dan Opalacz. We endured freezing nights sleeping in the back of his Toyota Highlander, nestled among surfboards in a makeshift platform bed. We'd park in state parks and in the abandoned driveways of summer vacation rentals, waiting for the sun to rise so we could check the swells. All of this continued to reaffirm my childhood fondness for road trips. Every time we were on the move it brought back the same visceral feelings of excitement, exploration, and independence—the feelings I first experienced as a kid riding above the cab in the RV as my family bombed the back roads of Northern California.

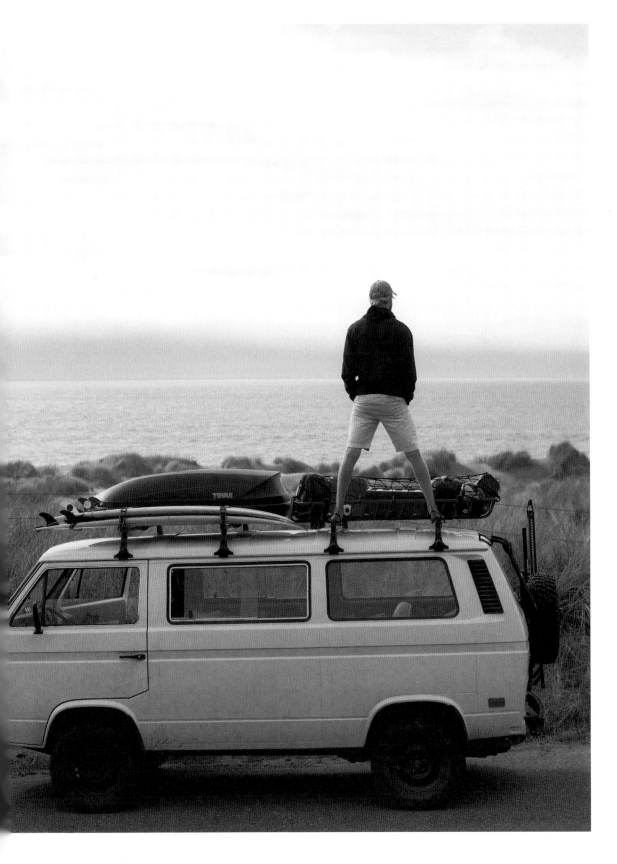

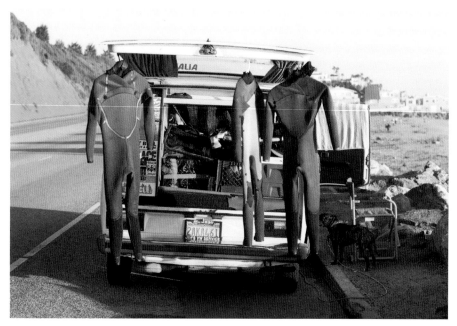

Previous page: Humboldt County, California; *above:* Malibu, California

My daydreams and memories contrasted starkly with what was becoming a more and more "grown-up" daily routine in Manhattan. Each day I arrived to work in midtown by 8 A.M. I ate breakfast at my desk for twenty minutes and would rarely return home before 8 P.M. I had landed what I thought was my dream job and was fast-tracking my way toward the security, comfort, and predictability that my generation was conditioned to want from a young age. To my peers it seemed like I was headed down the "right" path, but I struggled with the growing feeling that I wasn't going to live up to my expectations of what my life could truly be. With all this in mind, and using my dreams of a van as my catalyst, I started planning my exit from New York. Coincidentally, at this same time, a photo project of mine called *The Burning House* was getting some attention and had been picked up to be published. Adding the book advance to the other funds I'd been squirreling away, I started searching for a van to buy with a renewed sense of urgency.

I found the listing for my VW T3 Syncro in late May of 2011. It had all of the modifications I wanted: front and rear locking differentials, an engine swap (the stock waterboxer four-cylinder is infamously underpowered and prone to blowing head gaskets), upgraded suspension, off-road tires, and a fresh paint job. Like me, the original owners were from

Portland, Oregon, and they had babied the van since picking it up at the dealership in 1987. To this day, I still get goose bumps thinking about the moment I dialed the number on the listing and the owner of the van picked up on the other end of the line. Thankfully, everything checked out. It was the one. We agreed to meet at the Reno airport the following Saturday.

I was beyond ecstatic. I bought a one-way ticket to Reno, immediately put in my notice at work, and started packing up my apartment. During my remaining days in New York, I was in a waking dream, already scheming about modifications and customizations for my van. It was a weekender edition, meaning that it had a folding bed but not a kitchen or pop-top. To make it livable, I still had some work to do. I needed to build a small kitchen cabinet and storage for clothes and gear. To increase the usable space, I put a basket and storage boxes on the roof, which proved to be essential for storing bulky equipment on longer trips and for keeping my cooking and sleeping area tidy.

One week later, I left my apartment forever and caught a cab to JFK at 4:30 A.M. By 1 P.M. PST, I was waiting in the baggage claim at Reno International Airport with a duffle bag and a mountaineering backpack stuffed to the gills. I stood there in the arrivals area, eagerly waiting for my future home to come roaring around the corner. Even before I saw it, I heard the rumble of its modified inline four-cylinder (it had a engine swap from

Highway, Nevada

an Audi 80) as it echoed around the waiting area. (Many van owners I've talked to share similar experiences of the first time they saw and heard their van. They'll also talk at length and with similar passion about the misgivings of selling their van.) After exchanging the title and shaking hands, I left the old owners hugging and fighting tears in the parking lot as I headed north out of Reno on the 395.

For the next two years I wandered North America in my van, racking up over eighty thousand miles, chasing waves from British Columbia to Baja, Mexico. I slept in national forests, Bureau of Land Management areas, and friends' driveways. Sometimes I camped in remote wilderness and other times I'd be hidden in plain sight, parking for the night in towns and cities across the country.

I wandered North America in my van, racking up over eighty thousand miles, chasing waves from British Columbia to Baja, Mexico.

And like many VW Vanagon owners, I experienced my fair share of breakdowns. Although unnerving, the time spent troubleshooting, riding in tow trucks, searching for mechanics brave enough to dive into my van, calling around for parts, and crawling under my van, flashlight in hand, was an essential part of the experience and a necessary rite of passage to truly understand van life. During my travels I became a careful listener, learning to know my van's sounds—its creaks and pops, its grinds and scrapes. I got to know it intimately, in a way that's only possible when you live in your car.

It was my movement and my shelter, my freedom and my opportunity. In the van I met a whole new group of people who, through one process or another, made a series of compromises to live a similar life on the road. More than the beautiful places I saw or the fun that I had, the friends I met while living in my van have had, and will have, the longest-lasting effect on my life.

1981 Volkswagen Vanagon Westfalia Camper GL (Gigi)
Muskoka, Ontario, Canada
Contributed by Zachery Nigel

Volkswagen T3
Vans Archive

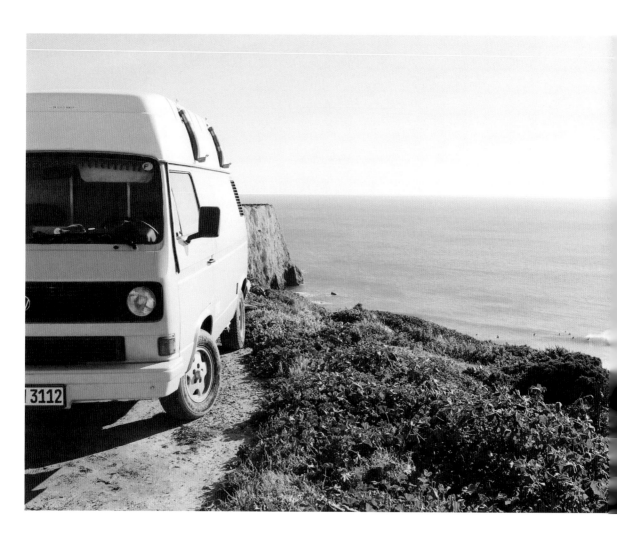

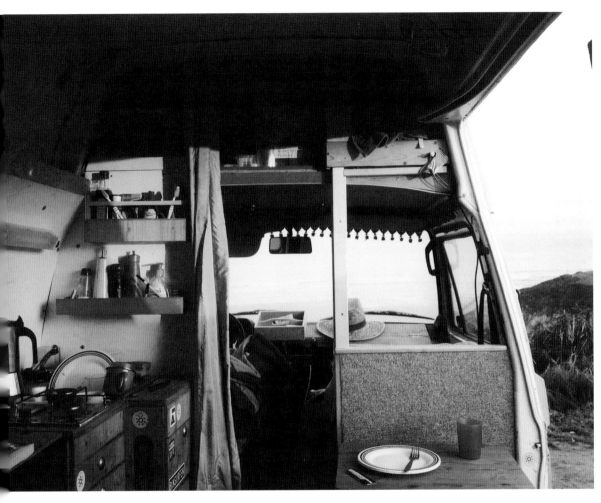

Left and above: 1986 Volkswagen T3 Postwagon
San Vicente, Spain
Contributed by Florian Obsteld

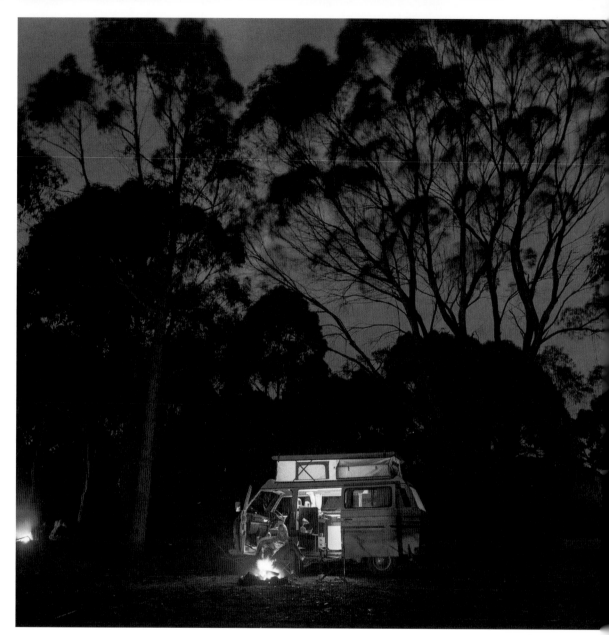

1989 Volkswagen T3 (Herman)
Above: Tasmania, Australia
Opposite top: Sydney, Australia
Opposite bottom: Adelaide, Australia
Contributed by Brook James

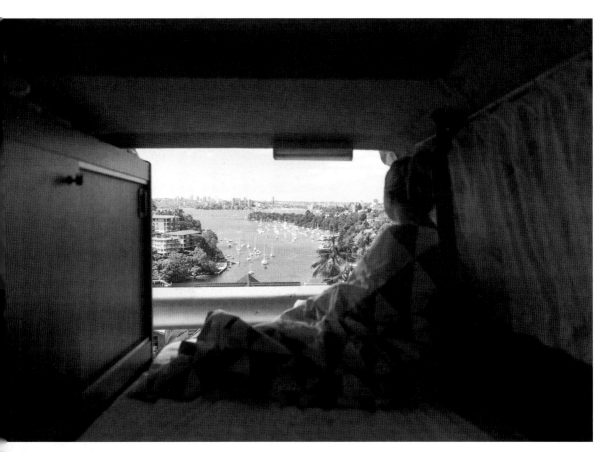
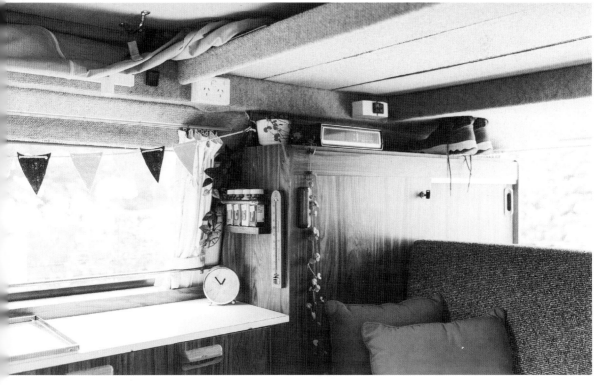

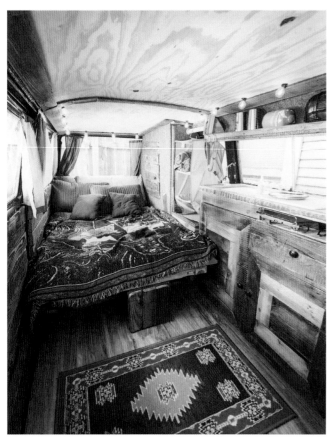

Left and below:
1986 Tintop Volkswagen Vanagon (Chewy)
Austin, Texas
Contributed by Brett Lewis

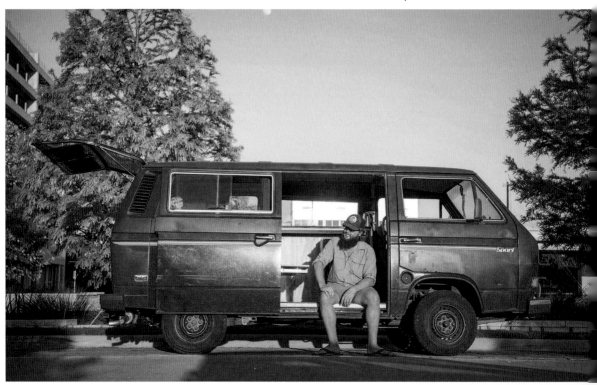

Right and below:
1986 Volkswagen Vanagon
Nooksack River, Washington
Contributed by Evan Skoczenski

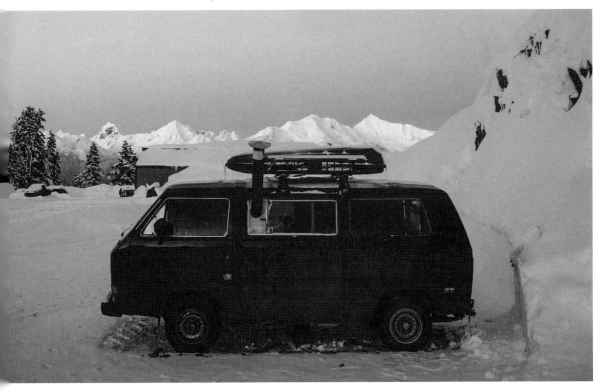

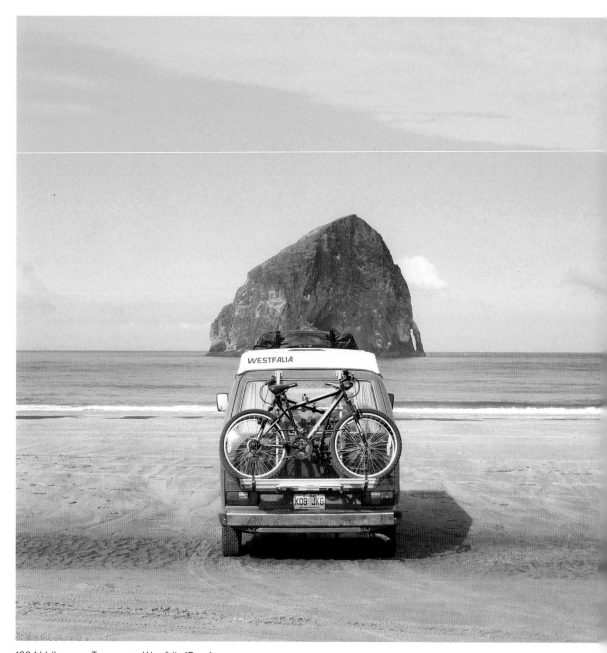

1984 Volkswagen Transporter Westfalia (Popo)
Above: Cape Kiwanda, Oregon
Opposite: Yosemite National Park, California
Next page: Saguaro National Park, Arizona
Contributed by Joanna Boukhabza and Eric Bournot

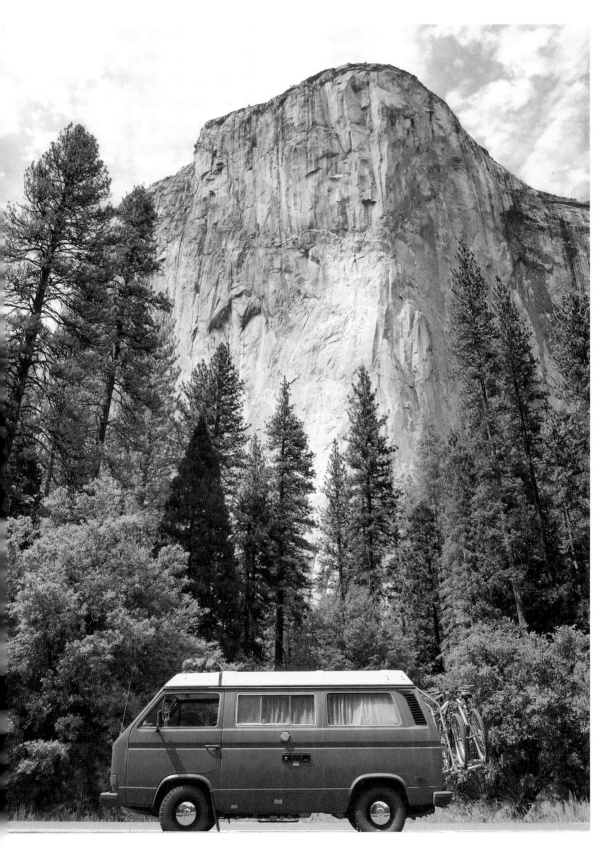

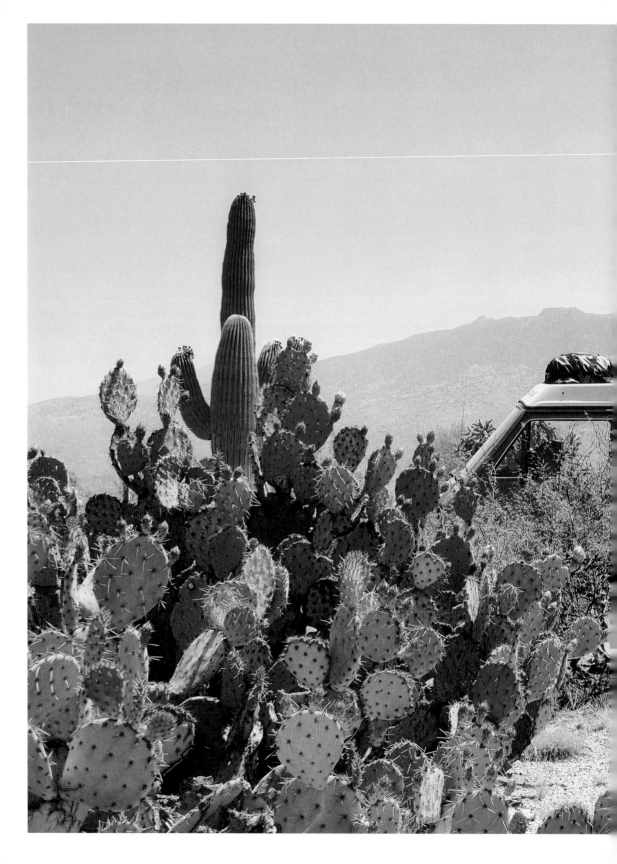

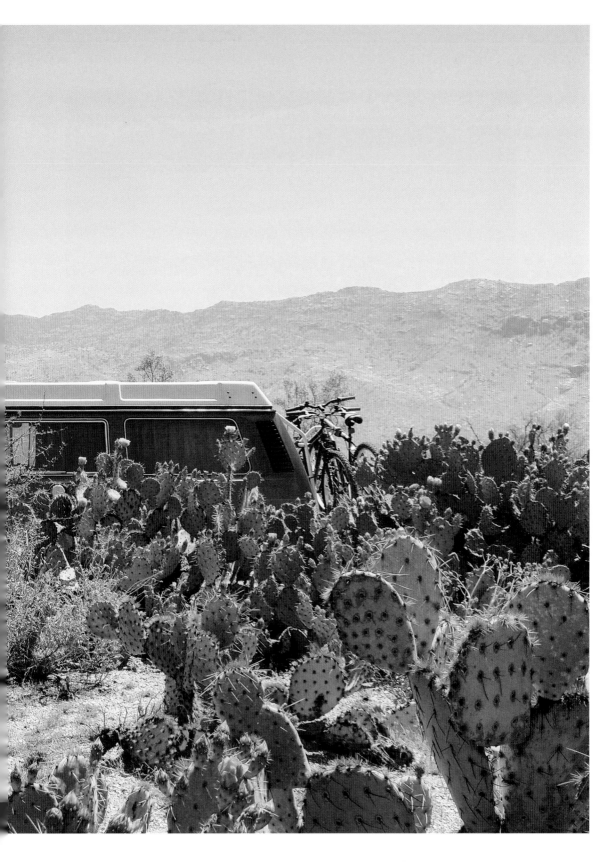

1997 Volkswagen Euro Van
Olympia, Washington
Contributed by Logan Smith

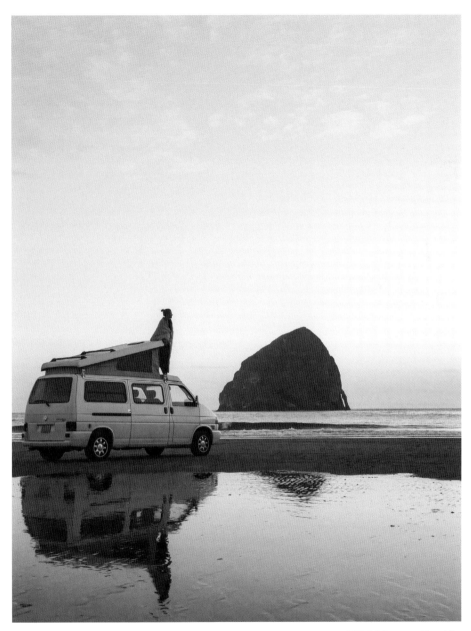

1997 Volkswagen Euro Van
Pacific City, Washington
Contributed by Logan Smith

1984 Volkswagen Vanagon Westfalia (Pushmills)
Talkeetna, Alaska
Contributed by Mike Pham

1984 Volkswagen Vanagon GL (Hayduke)
Indian Creek, Utah
Contributed by Jennifer Callahan

1981 Volkswagen Vanagon Westfalia Camper GL (Gigi)
Muskoka, Ontario, Canada
Contributed by Zachary Nigel

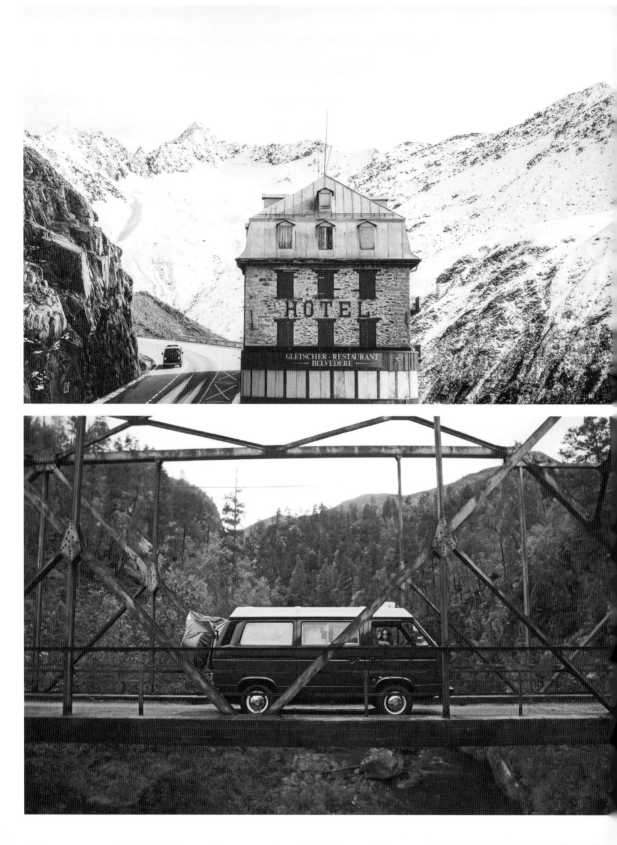

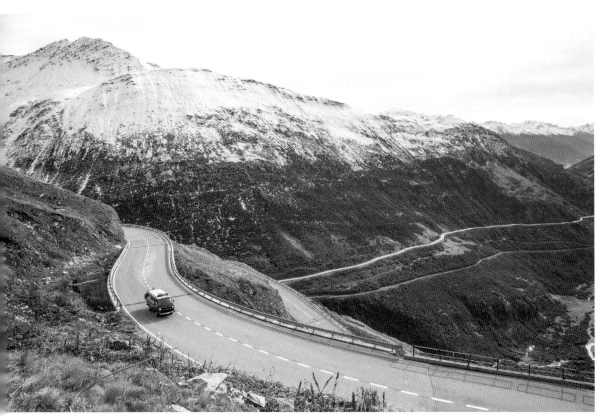

1987 Volkswagen Multivan Westfalia (Greta)
Above: Furka Pass, Valais, Switzerland
Opposite top: Dolomites, Trentino, Italy
Opposite bottom: Furka Pass, Valais, Switzerland
Contributed by Road for Greta

Next page:
1981 Volkswagon Vanagon Westfalia (Poppy)
Left: Cedar Breaks National Monument, Utah
Right: Cathedral Gorge State Park, Nevada
Bottom: Zion National Park, Utah
Contributed by Megan Matthers

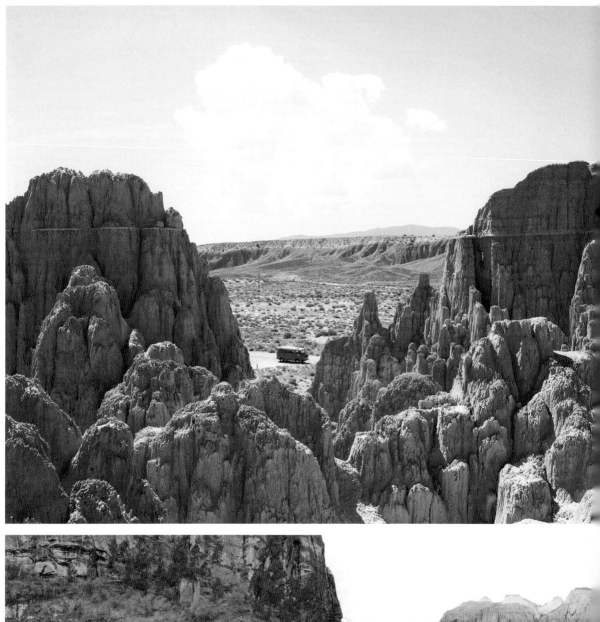
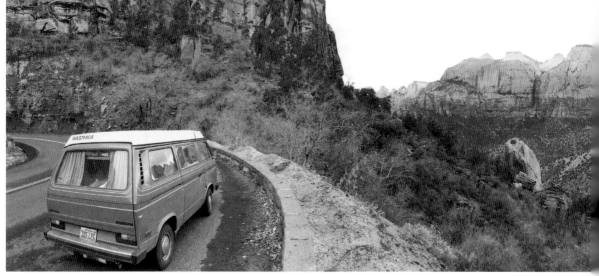

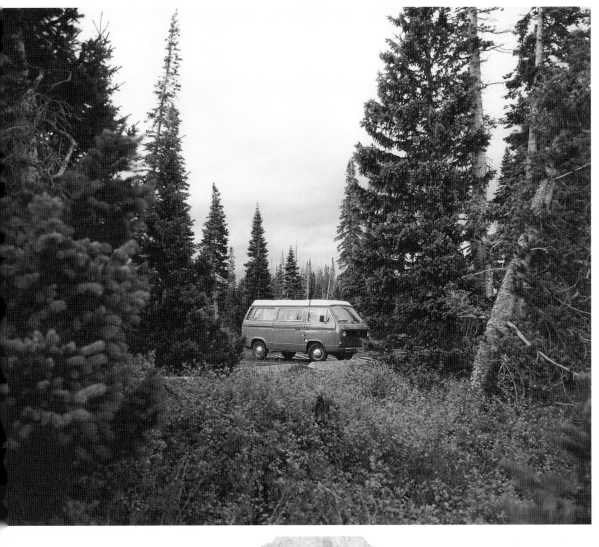

CHAPTER 2

VOLKSWAGEN T2 AND T4 VANS

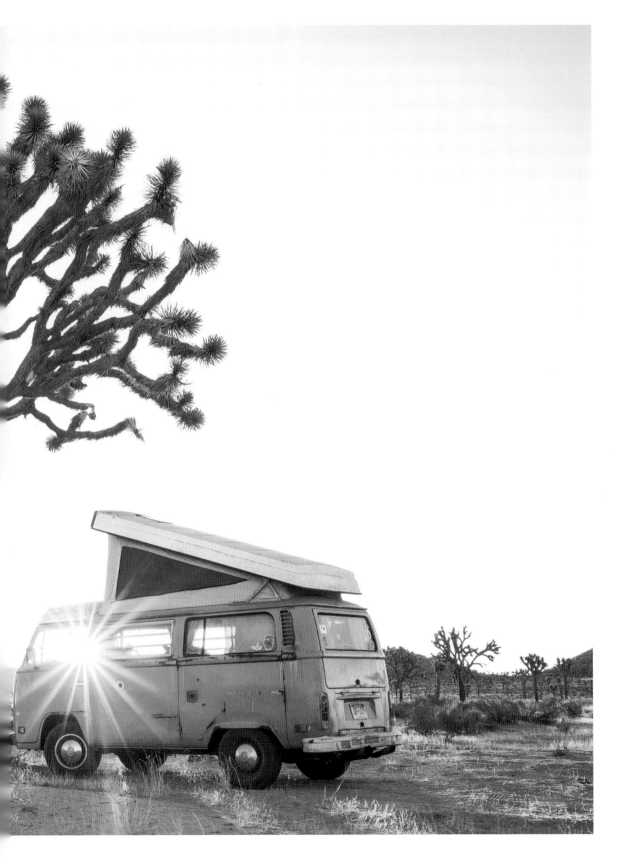

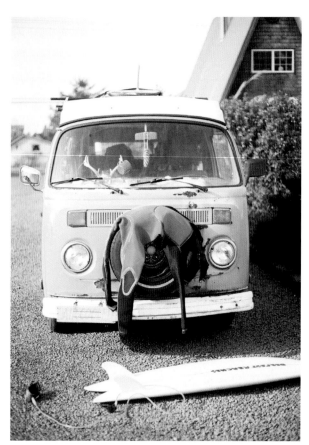

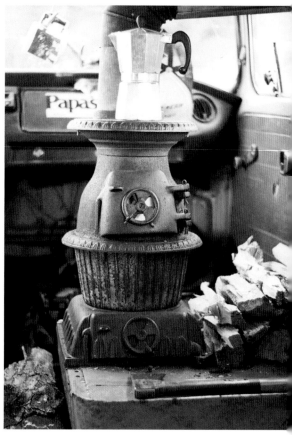

Previous page:
1976 Volkswagon
Westfalia
Joshua Tree National
Park, California
Contributed by James
Barkman

Clockwise from the left:
Pacific City, Oregon;
Brookings, Oregon;
Joshua Tree National
Park, California

Lost out West: James Barkman gets to know every corner of the Pacific Northwest in his unconventional Volkswagen campervan.

I've been keeping up with James for a few years now (it's not easy) as he bombs up and down the West Coast in his yellow T2 in search of the best and most remote waves and climbing spots. From British Columbia down to Baja, he's a young-gun adventurer who's completely on his own program. Photographer, surfer, snowboarder, dirt biker, mountaineer, mechanic—he embodies the self-reliant van life in its purest form. There's no final destination with James, just constant movement. He's always in search of the next apex experience. I finally nailed him down for a chat and he laid out his game plan for the next couple years of life on the road.

FOSTER: So what's been the most terrifying moment in the van so far?

JAMES: Having a wheel bearing go out at sixty miles per hour in the rain. You're rolling on your spindle instead of the bearings. It's terrifying for sure. And that was in rain, in a storm, in January near Tacoma, Washington. It was so ridiculous.

FOSTER: What modifications have you done to your van?

JAMES: Honestly, only the woodstove. There's nothing that I've really needed to do. It's pretty amazing. Everything that they made back then doesn't really need to be changed. There's no wasted space. Everything has a purpose. I just ripped the seat out and put the stove in. I put hardwood floors in and then put in a head temp gauge. But nothing much as far as interior stuff. I've left it how it is, because it works.

FOSTER: How'd you track down the woodstove?

JAMES: A long time ago I had seen a video on the Internet of a crazy Russian dude who had a Volvo wagon and he put a woodstove in his passenger seat and had it vented out through the top. It just made a lot of sense for the van, because I didn't want to deal with propane heat for the winter. So I just started looking for marine stoves on craigslist and then I found the one I have for forty bucks. I got an Amish guy to fabricate some missing parts. I just fit it in, bolted it down, and figured out how to run the pipe through the window. It works great. I can disassemble it in thirty seconds. I can pop it off, stash it, and go.

FOSTER: When did you decide to move into a van?

JAMES: I was twenty. At the time, I wasn't into Instagram or any of that. I just knew that I loved my van, and was learning more about it and camping in it like five nights a week, while still living at an

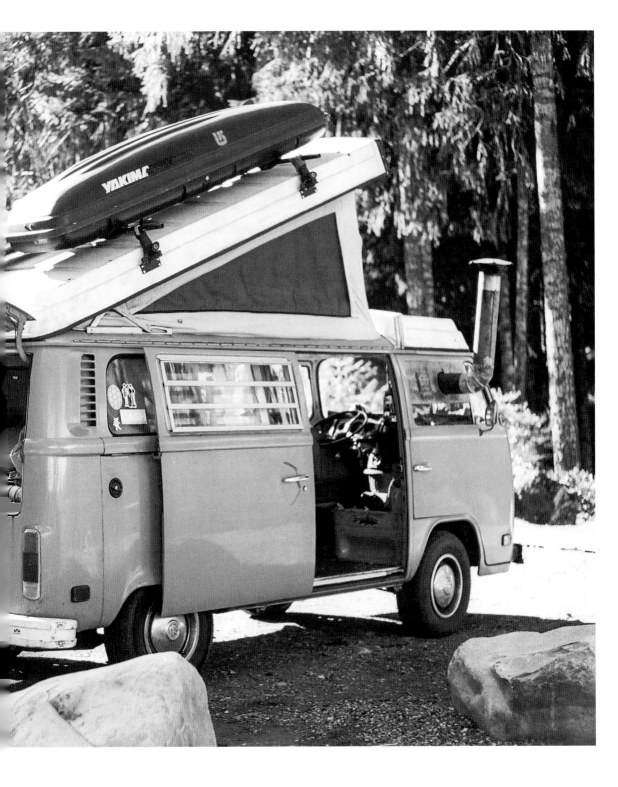

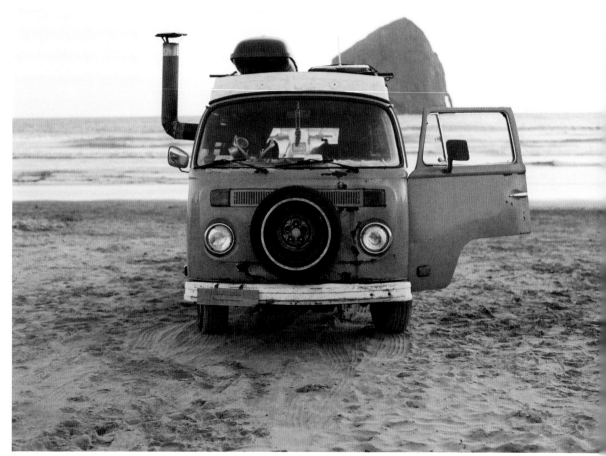

Previous page: Olympic
Peninsula, Washington;
top: Pacific City, Oregon;
bottom: San Luis Obispo,
California

apartment with some friends. It was so dumb, I was paying money to live in an apartment and I was never there. It just made sense to move out and be in the woods. As a kid all I wanted to do was live in the woods by a river and mountains or the ocean, but I grew up in rural farmland with cornfields and I hated it. My family had a little cabin out in the woods and as a kid I spent as much time there as much as I could. That's what I've always wanted to do and that idea never left me.

FOSTER: When did you start taking photos?

JAMES: I've always kind of been doing little video projects. My first camera was a Polaroid before I could afford a digital or anything, so I was always taking pictures, but I wasn't trying to "make it" or take it seriously until a few years ago.

It was so dumb, I was paying money to live in an apartment and I was never there.

FOSTER: What's the worst breakdown you've had?

JAMES: The most expensive one was when I burned a head in Maine. I was stuck for a week, but we stayed on a friend's sailboat so it wasn't so bad. Just expensive to fix. My worst breakdown? It's so hard to define "the worst" because some are just way more stressful. I got stuck in Joshua Tree National Park in California and I didn't have money to get towed or money to buy parts. One time my solenoid went out in the rain and I was by myself at least ten miles back on a forest road. I couldn't get my van to start, but somehow I figured it out. But I had to pull the entire motor out to work on the starter, so it wasn't pretty.

FOSTER: How much time do you spend up in the mountains versus the coast?

JAMES: Honestly, I've probably spent more time in the [Olympic] Peninsula, by the water. I love the mountains, but it's hard to be so far from the coast. I'll be somewhere inland and see a report coming in and I'll miss a swell. I haven't seen as much of the Northwest as I've wanted to because it's too easy to stay by the coast and surf when there's a wave.

FOSTER: What's your plan for winter and into the next year?

JAMES: I'm going to work through the winter, then in June some buddies and I will leave for Patagonia. My friends are leaving from Pennsylvania, going up through Canada, and I'll meet them up in Alaska. We're still deciding on some details, but we're driving from Deadhorse, Alaska, all the way down to Patagonia. It'll be about thirty thousand miles total and because we're self-funded we don't have a deadline, but it will probably take six months to a year.

FOSTER: What do you want to do? Are you going to shoot a video?

JAMES: I want to do a book. A video is so much work. I think I would be able to do a book better. On our trip we'll also be climbing a bunch of mountains as well and it's so hard to shoot good video and, more importantly, bring all the camera gear. We're already going to be hauling all our mountaineering stuff. I think it would be too much. I've even considered doing this entire trip without taking a single photograph. It's something that I've wanted to do for a long time, but it would be a waste to be there and not shoot it well. Obviously we won't be the first ones to do it, but we can always do it a little differently.

FOSTER: Can you ever see yourself settling down?

JAMES: To be honest, I don't think so. To me, living unconventionally isn't just a fad or trend; it's always been a part of who I am at the core. I see my van as a means to an end, not an end in itself. Whether I live in a van, on a boat, in a tent, or on the back of a motorcycle, I want to pursue the things that I perceive as valuable, and I see my current lifestyle choices as a way to steward just that.

Pacific City, Oregon

Opposite:
1977 Volkswagen Westfalia
Bonneville Salt Flats, Utah
Contributed by Callie McMullin

Volkswagen
T2 and T4 Vans
Archive

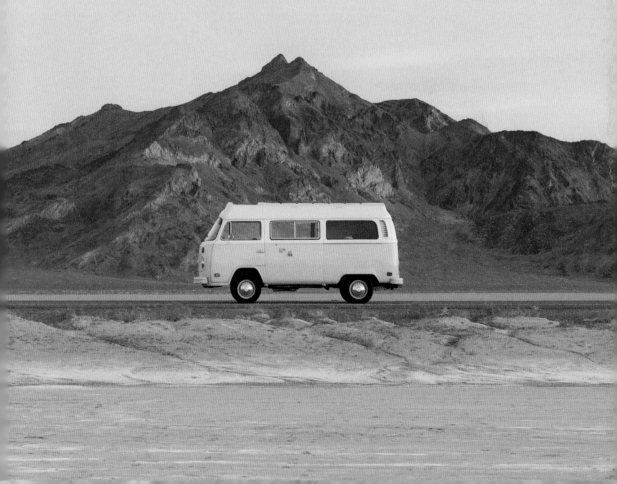

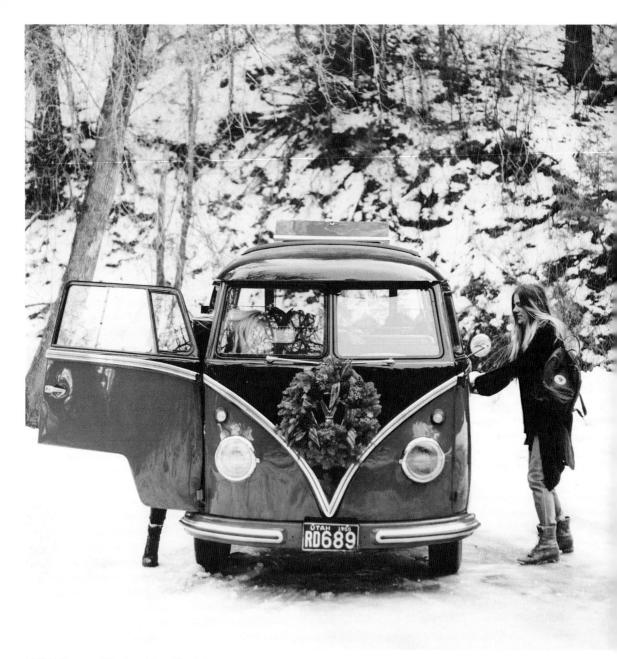

1955 Volkswagen Microbus deluxe (Samba)
American Fork Canyon, Utah
Contributed by Callie McMullin

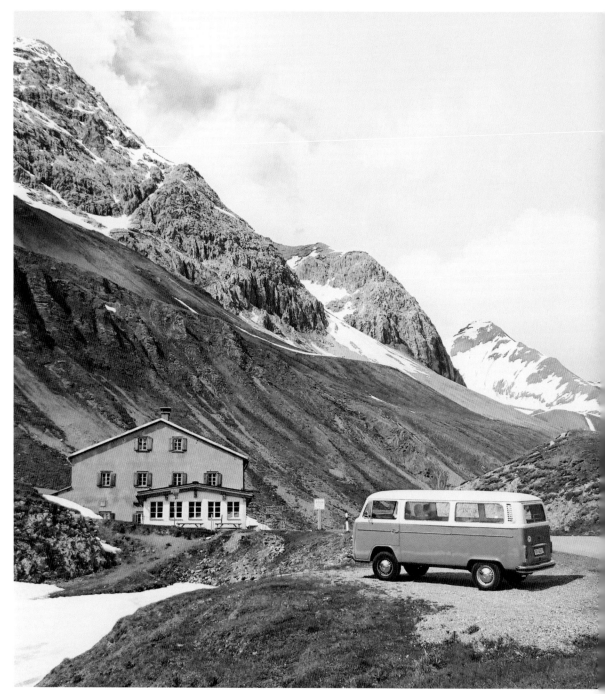

1977 Volkswagen T2 Kombi
Above: Albula Pass, Switzerland
Opposite: Davos, Switzerland
Contributed by Martina Bisaz

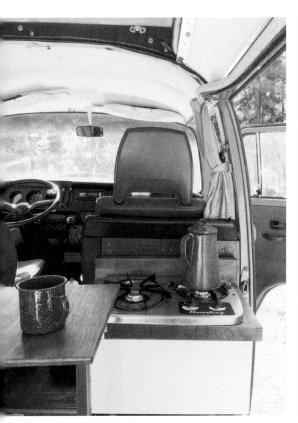

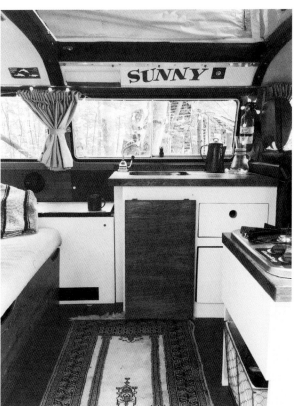

1978 Volkswagen Bus (Sunny)
Opposite: Mackinaw City, Michigan
Left: Cle Elum, Washington
Right: Medicine Hat, Alberta, Canada
Contributed by Alex Herbig

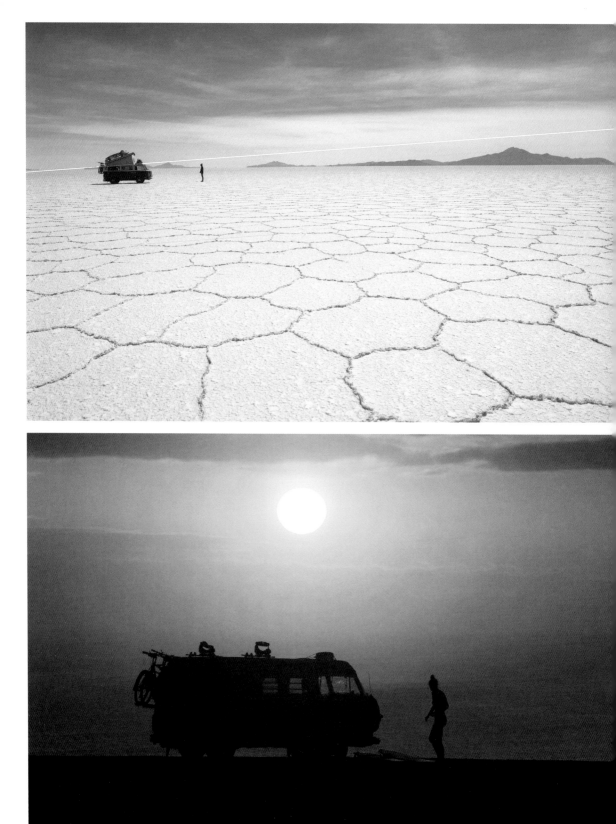

1978 Volkswagen Westfalia Champagne Edition (Oscar)
Above and opposite top: Salar de Uyuni, Bolivia
Opposite bottom: Puerto Chicama, Peru
Contributed by Mark Galloway and Bec O'Rourke

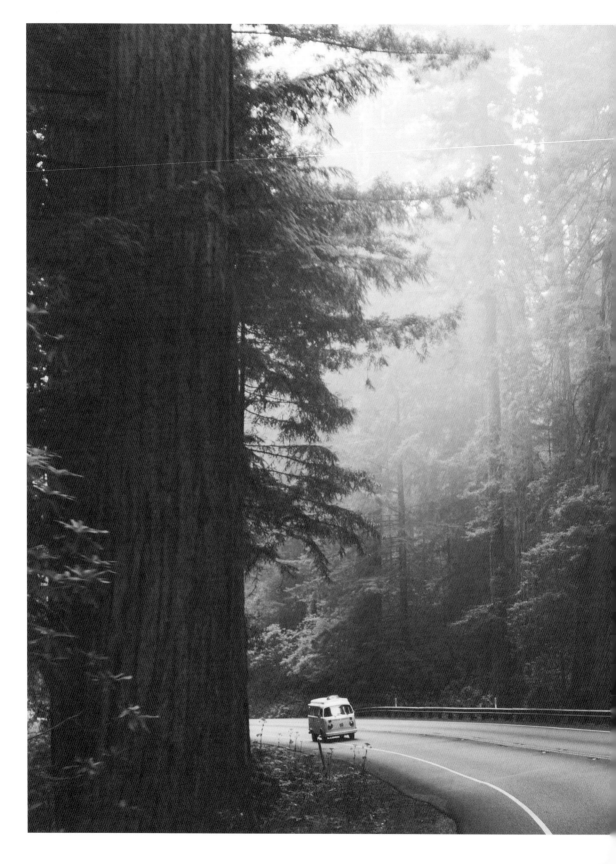

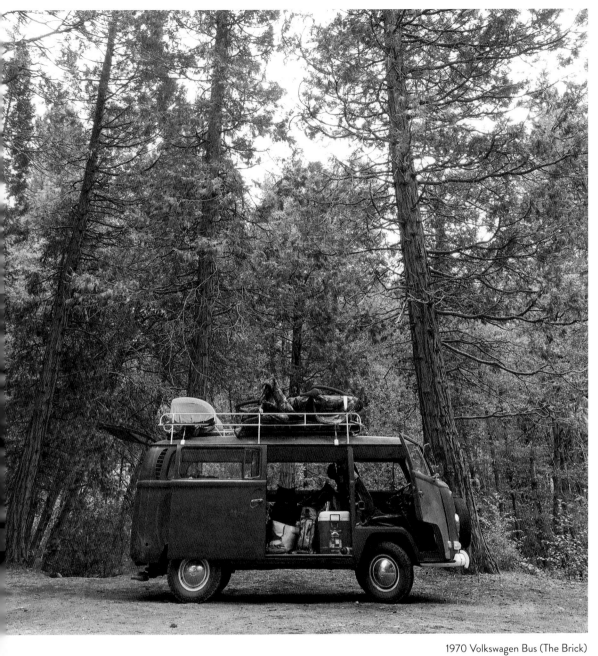

1970 Volkswagen Bus (The Brick)
Camp Nelson, California
Contributed by Sean Talkington

Opposite: 1977 Volkswagen Westfalia
Redwoods State Park, California
Contributed by Callie McMullin

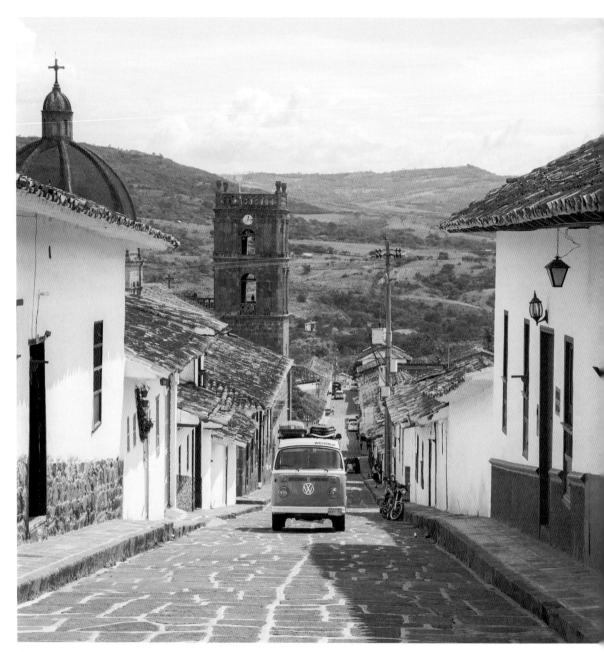

1975 Volkswagen Westfalia (Rita)
Barichara, Colombia
Contributed by Dillon Vought

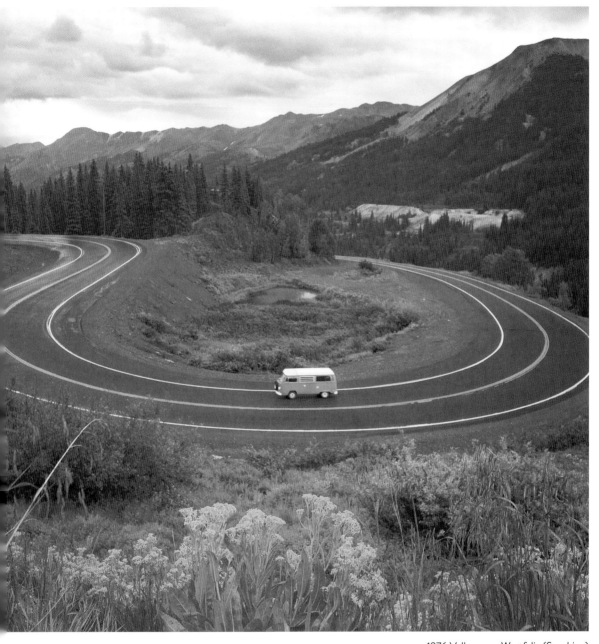

1976 Volkswagen Westfalia (Sunshine)
Million Dollar Highway, Colorado
Contributed by J.R. Switchgrass

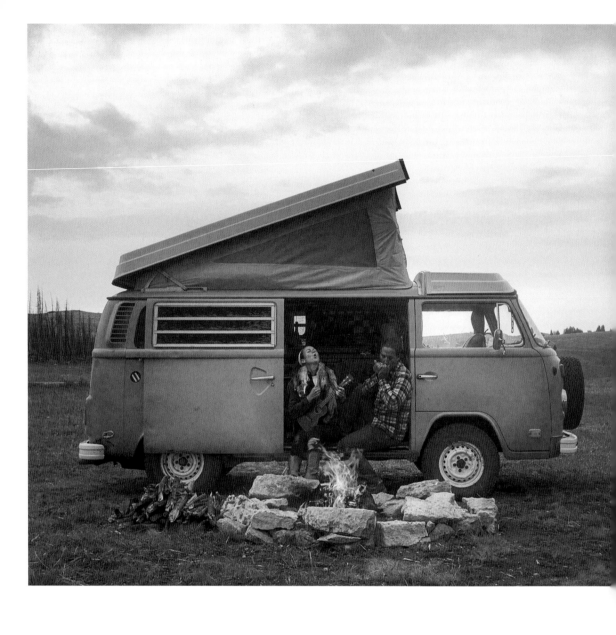

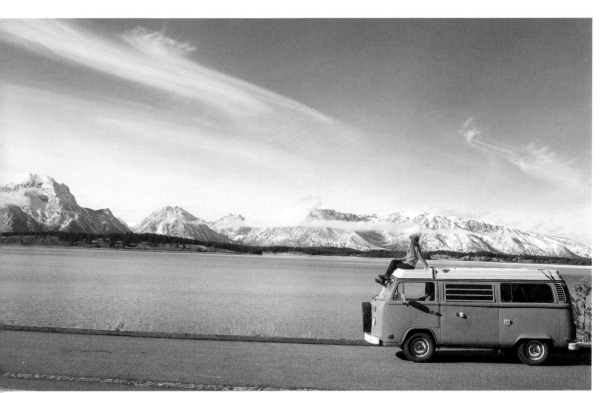

1976 Volkswagen Westfalia (Sunshine)
Above: Grand Teton National Park, Wyoming
Left: Bonneville Salt Flats, Utah
Opposite: Bighorn Mountains, Wyoming
Next page: Canyonlands National Park, Utah
Contributed by J.R. Switchgrass

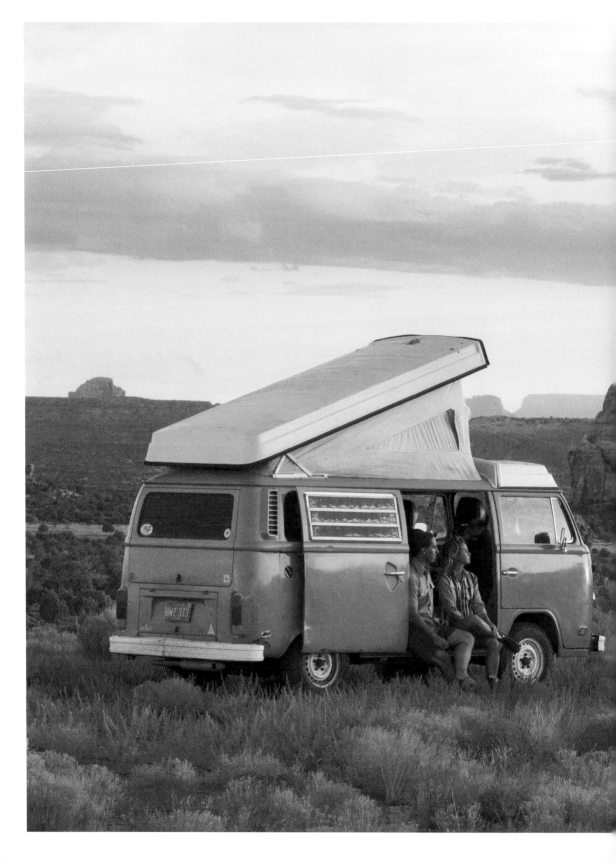

Top: Newport Pagnell, England; *bottom*: Hossegor, France

Still rolling: Callum Creasy's Volkswagen T4 gets a new lease on life as he plots another European adventure.

It was reassuring, years ago, when I landed on Callum Creasy's *The Rolling Home* blog. I was also documenting my journeys—writing, taking pictures, and keeping up my blog. It made me extremely happy knowing that there were other people like me, doing something similar halfway across the world. Based in the UK, Callum has logged tens of thousands of miles in his VW T4, all across Europe and up into Scandinavia. In addition to publishing *The Rolling Home* book, Callum is now periodically putting out *The Rolling Home Journal*, which moves beyond campers, vans, and buses and explores the idea of alternative living at a broader scale. It was great to catch up on the phone, but I'm hoping we can meet in person sometime soon.

FOSTER: So how and when did you find the T4?

CALLUM: Before the T4 I had a Nissan Vanette—that's like a pretty weird and ugly-looking van. It was bright red. We bought it for like seven hundred quid when I was seventeen, and we converted it. We used it for a summer of surfing in France, then we decided to go to something bigger. So we looked at a Peugeot Boxer van. I never wanted a T4 because they're so expensive and they were way out of our price range, but then this T4 popped up on eBay for like fifteen thousand quid, which is a really good price. We offered him twelve thousand and he was like, "Yeah, no worries." That first summer we went away and just threw a blow-up mattress in the back and did a trip around the UK. The rest is history, I guess. We slowly converted it and just kept adding to it.

FOSTER: So when did you put that hightop on, and those bitchin' little circular windows?

CALLUM: We had it for four years before we put the hightop on. It was completely random. I found it on eBay. I'm always browsing at vans, and the hightop was on there for silly cheap in Wales, about six hours away. So we rented a sprinter to go get it and then it took me about a month to buck up the courage to actually cut it off, but once I did it, it was like, "Oh my god, we've got so much space." The little porthole was off a canal boat that I also found on eBay. I guess I wanted to do something different. The porthole was the perfect way to retain a bit of that old-school adventure feel.

FOSTER: I spend so much time on eBay. I buy everything on eBay.

CALLUM: Every vehicle I've ever owned has come off of eBay. What would we do without it?

FOSTER: So how many miles have you put on the T4?

CALLUM: We got it when it was just under 100K and now it's done 215K. To be honest, though, it's our only vehicle, so we use it as a daily driver as well. It's done us proud, and we had a big refurbishment from the cash from the book, which was a dream come true. It wasn't very economical because it's not worth the money we spent on it, but...

Newport Pagnell, England

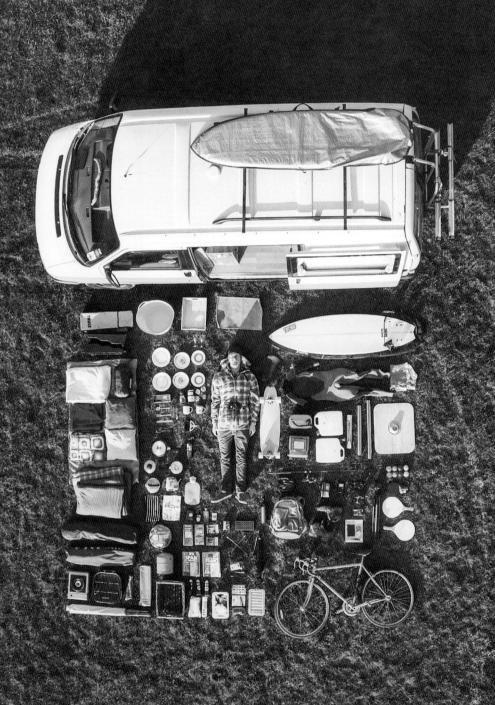

FOSTER: You can't get rid of it.

CALLUM: That's it. Exactly. We can't. I rebuilt the engine a couple of years ago. I had to have a new head and it was retimed, but it's still going strong.

FOSTER: Have you ever wanted to go to Africa? Go down to Morocco?

CALLUM: I do. I want to drive to South Africa. I did a job over in Kenya a few years ago and we were in absolutely the middle of nowhere and there was a German Sprinter van down there in Kenya just chilling next to this watering hole and I was like, "Wow. I've got to bring the van down here." I'm working on it. I'm building up the courage to take it down there.

FOSTER: I went to Morocco in 2013 and the whole time I was there I was thinking, "I gotta come back in a camper." The waves are insane, there are so many cool campers and it's such a better way to travel around there.

CALLUM: Morocco has traditionally been the end of the "run to the sun" route for Europeans. There's that well-worn path through France and Spain and into Morocco. We've been to where you can get the ferry, we just haven't done it yet. I guess it's nice to have some places on the list still to do.

FOSTER: That's one thing that's nice about being so close to Europe. You can go anywhere from there. It's so easy to drive around there.

CALLUM: We take it for granted. We drive through five different countries in a day. It's so diverse culturally and language-wise. It's incredible. We went up to Scandinavia on a round and ever since we've been besotted by that Nordic vibe.

Cornwall, England

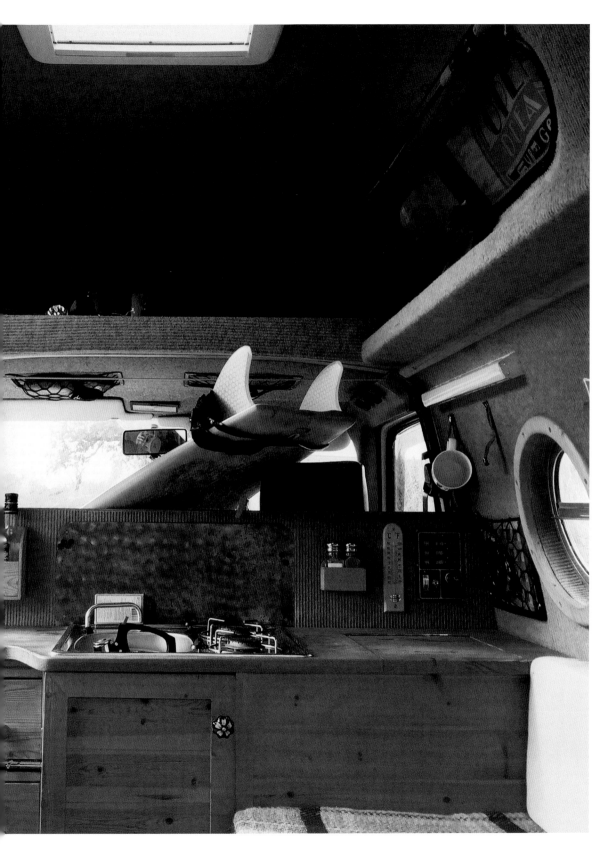

FOSTER: I've never been up there. I really want to. It seems so cool.

CALLUM: It's the most van-friendly place to go in Europe. You can camp wherever you want. You can park wherever you want. In Sweden especially, they have a very forward-thinking approach to conservation and the outdoors is a huge part of the culture.

FOSTER: What's it like parking in the UK?

CALLUM: It's really bad, actually. Wherever there's a free bit of land there will be a "no camping" sign, especially down here in Cornwall. But saying that, if you're audacious and just go for it, most of the time you're fine. The worst you're going to get is the landowner banging on your door in the morning, which, when we were younger and surfing down in Devon, happened frequently. In fact, every time we parked in the same spot we'd get this farmer banging on our door in the morning, which of course we used as a wakeup call.

We human beings are, by our sheer nature, transient.

FOSTER: So you're living in an apartment now? Are you out of the van?

CALLUM: We left on a trip in March and we were going to be in the van indefinitely. We went away for three months but in that time we realized it was a lot easier to be in one place. It can work, but in the long term it just doesn't. Even more, it takes away from that special vibe, because the van is a way to escape, so then setting up your work there is completely wrong. It just doesn't feel right.

FOSTER: One of my favorite parts about living in a van is all the people and community that I have met. Have you met some amazing people?

CALLUM: For sure. Some of our closest friends. Europe is really cool because we met some German guys in northern Spain and then hung out with them when we cruised through their country. It's all good fun.

FOSTER: What's more important to you, the idea of "home" or "movement"?

CALLUM: The fact is, with a van or any vehicle that you chose to spend time in, it has the potential to fulfill both—there's no need to choose. You have both a place to call home and the ability to take that home where you please. Maybe this is the magic that we all discover, whether you have traveled for a short time in a campervan, or you live full-time in your truck.

We human beings are, by our sheer nature, transient. Our ancestors were nomadic; they would move across the land in search of food and a safe place to make camp. When we choose a vehicle as our home, that ancient part of us turns on, it starts working. You can feel it every time you wake up somewhere new. It is part of who we are and the incredible thing is that right now more people are finding that than ever.

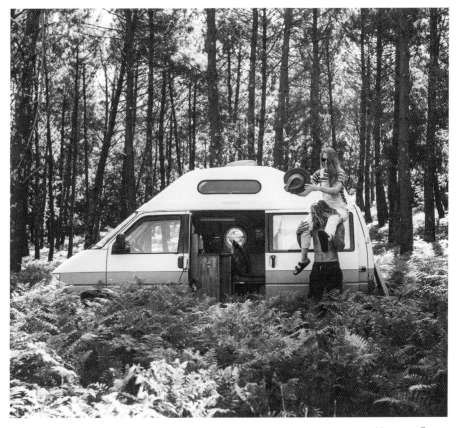

Hossegor, France

CHAPTER 3

SPRINTER VANS

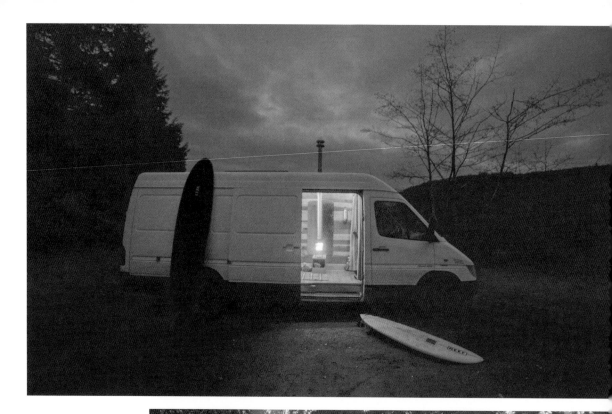

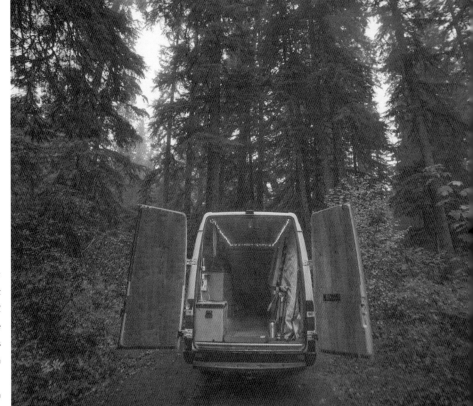

Previous page:
2008 Mercedes-Benz
Sprinter L2H2
Gorge du Verdon, France
Contributed by Jens
Hruschka

Top and bottom: British
Columbia, Canada

On the edge: Cyrus Bay Sutton's converted Sprinter offers simple space and a quiet place to work just outside the boundaries.

Cyrus is relentless. As a filmmaker, editor, writer, and innovator, he never takes his foot off the gas. For him, living in his van has always been about unlocking his creative passions—a means to an end. Because of this, he always brings a totally fresh perspective, one that avoids over-romanticizing living out of your vehicle. Instead, he's more focused on the realities, the hacks, the DIY solutions, and the hard-earned wisdom that can only come from a full decade of van life experience. I like Cyrus because he has an edge to him. His Sprinter isn't an escape—it's a solution, a mobile workspace, a quiet place to focus, an act of personal and financial independence. Our paths always seem to keep crossing, and I feel lucky that he's so generous in sharing what he's learned.

FOSTER: What was your first van?

CYRUS: I first moved into my van in 2005. It was an electrician's panel van. It had no windows with electrician racks. I bought it off a guy who had modified it just a bit with beefier suspension and off-road tires and rims to be a support vehicle for The Baja 1000 off-road race. I moved into that when I was twenty-two.

FOSTER: At that point you weren't living full-time on the road traveling and surfing in the West. I think you were in Southern California working. It was an alternative to an apartment, as opposed to a vehicle for exploration.

CYRUS: It pretty much always has been. I think that people have this idea that I'm living in all these amazing national parks, adventuring around. It's really just a means to an end, because what I really love to do is make films and write. It has always provided me a space to do that. To get inspiration by changing my location. Some projects take a lot of time, and the wall I would always run up against was feeling stagnant from spending a lot of time in front of the computer. It's really nice to drive somewhere new at night, open your door, and spend part of your day outside.

It didn't have to be wilderness—for me it was always about the local mountains or the desert behind LA. I'd go to different zones and areas that weren't popular. They're not spots that have tourist books written about them. They're just forgotten places where I could be by myself. I could go to the local grocery store. I could get Internet and just work.

They're just forgotten places where I could be by myself.

FOSTER: So you'd work and then you'd travel. I know you're a big fan of going out to the desert to edit on your laptop. I imagine it was a chance to reset and stay positive while you're taking on these gnarly projects.

CYRUS: Yeah, editing gets to be pretty monotonous. I spent a lot of time in Baja before I got my van. It allowed me to go down there to work, to a certain extent. I was editing a

High Desert, California

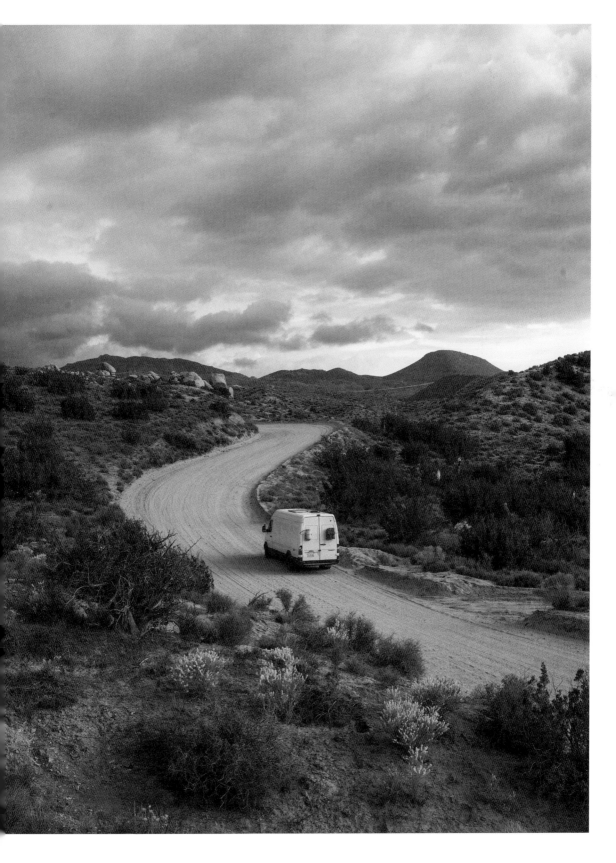

huge endeavor for me at the time—a film called *Under The Sun*, a surf film about Australia. I shot it on 16mm film and taught myself how to animate and rotoscope on After Effects and Photoshop, which is an incredibly tedious process where I would spend a week creating seven seconds. I was making an hour-long movie that I was layering all this stuff onto.

Living in Orange County, I spent the first three years living in a van in Costa Mesa and I was sleeping in the parking lot of the record company that had commissioned the film. I was surfing every morning, and it was this great way to be really close to the beach and really close to work. I could shit, shower, and shave at 24 Hour Fitness. Everything was simple. There was no security deposit. No rent. My only expenses were food and gas in my tank, because I bought the van outright. All this allowed me to save money and get work done.

FOSTER: So it allowed you to save money and buy a house and eventually break the rent cycle?

CYRUS: Yeah, it's allowed me to do what I'm doing now: Buy a house. Own land and plant trees. So now I live in your part of the world [the Columbia River Gorge in the Pacific Northwest], which is the kind of place I'd park on my trips. I would always find zones that were like twenty to twenty-five minutes from town, where you'd go in and get supplies but still have the peace and quiet of nature. The van always allowed me to go out there and then dip into the city for a meeting or go to an edit house or pick up a job. I could spend the night. I could take a nap if I was tired. Southern California didn't get to me as much when I could just hop in the back and be in this cocoon.

FOSTER: Talk to me about the evolution of your van. It was interesting that you've mentioned to me how you were almost like dangling a carrot out in front of yourself, like incremental improvements kept it manageable.

High Desert, California

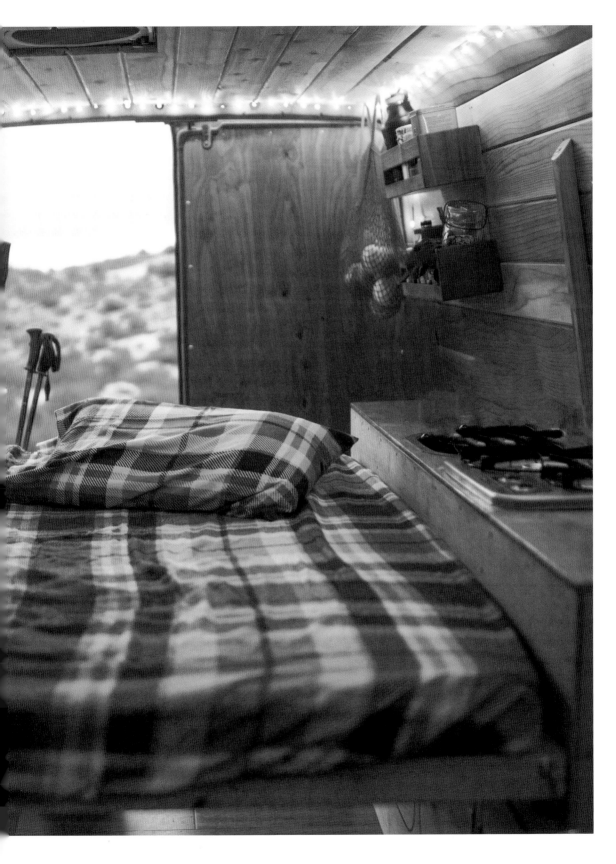

CYRUS: Yeah. But that's in retrospect. I wasn't trying to do that. It was about resources and learning. I really relish how poorly designed my original van was. I am a firm believer that "comfort" is a relative term. For me, living in a van is not comfortable; it's not as comfortable as living in a house, but what I traded in comfort, I got in freedom and flexibility. I think today we live in a really weird dichotomy where we live in places that are really big and really comfortable, but then you feel totally exposed when you go out into the world.

But if you're living and working out of a van, if you're traveling and you're trying to be creative and you're not just going to the same job every single day, if you're an entrepreneur or a freelancer, then you're constantly making different routes and working different places, and having a van is part and parcel of that lifestyle. You can have some semblance of comfort all the time as opposed to having to go back to your house, through traffic. With a van you can avoid that. On weekends I won't go out to the countryside, I'll do the opposite of what everybody else does. You can migrate and escape the typical patterns more easily in a van.

FOSTER: So how has your van evolved?

CYRUS: When I first had my van it was really poorly designed. The shelves served no other function but just taking up space and holding a bunch of stuff that wasn't well secured, so it fell out all the time. I had a sheet of wood that housed Rubbermaid plastic bins that were

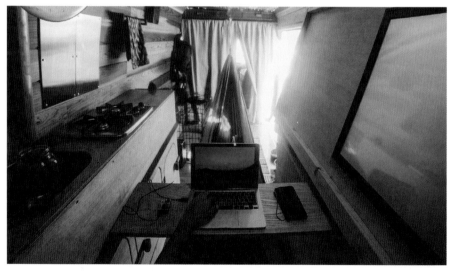

Malibu, California; *opposite:* Encinitas, California

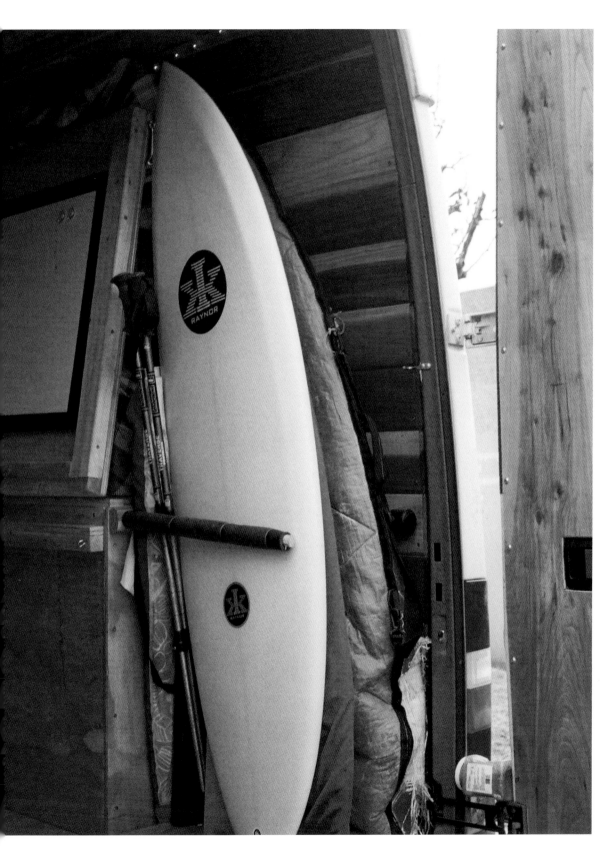

full of a bunch of stuff that was held in place by bungee cords, but not really. I had a fixed piece of wood that was my bed, and that was it. No kitchen. Nothing else. Everything was uncomfortable. I was constantly stepping over thing and things were rattling around. I'd organize and clean and then I'd turn around after driving and I just lived in chaos.

So slowly I chipped away. I got more organized, but I wasn't willing to give up the freedom and move into a place. I had to make it work. The big move was kitting out the inside with Glen Horn, who's been living out of an old milk truck for the last thirty years. He really helped integrate my build-out. I'd make storage part of a cooking unit or part of where I slept so that it got organized, and the saying is true: "out of sight, out of mind," and the chaos doesn't get to your brain. I had also spent a lot of time in Japan. When I was growing up my dad got an exchange teaching job there, and I go back every year. I've always been inspired by their use of space. In Japan they have a tenth the amount of space, but it doesn't feel small because everything has multiple purposes—the bed rolls up, there are no fixed interior walls, just these sliding doors. It's so much more efficient and it gives you a feeling of calm.

FOSTER: Do you ever see yourself not having a van? I mean, can you envision a scenario where you won't have an escape pod of sorts?

CYRUS: I just can't imagine it. Hitting the road in my van is a reset button that I've gotten used to. The quiet days on the road have given me so much that regardless of how my life plays out, I'm sure I'll always have an escape pod in the driveway.

High Desert, California

Opposite:
2005 Renault Master LWB (Walter)
Mazarron, Spain
Contributed by Freddy Thomas and
Gabriela Jones

Sprinter Vans Archive

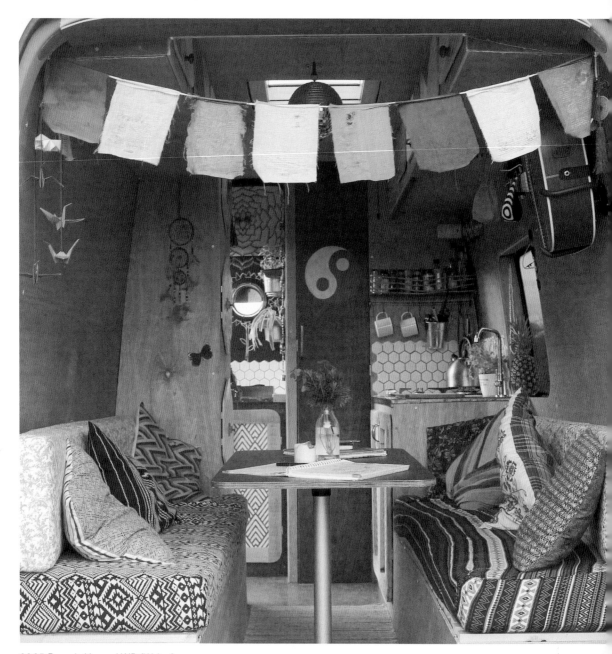

2005 Renault Master LWB (Walter)
Above: Alentejo, Portugal
Opposite: Brittany, France
Contributed by Freddy Thomas and Gabriela Jones

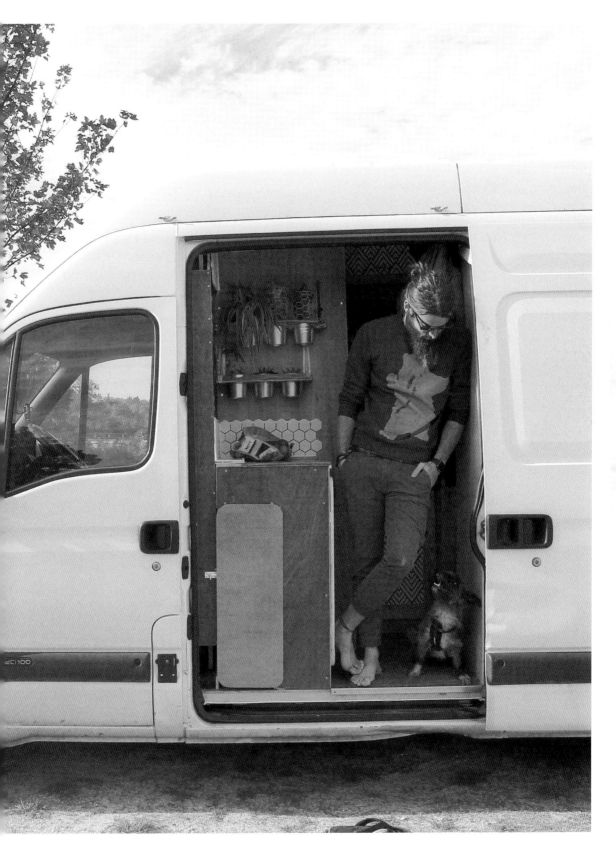

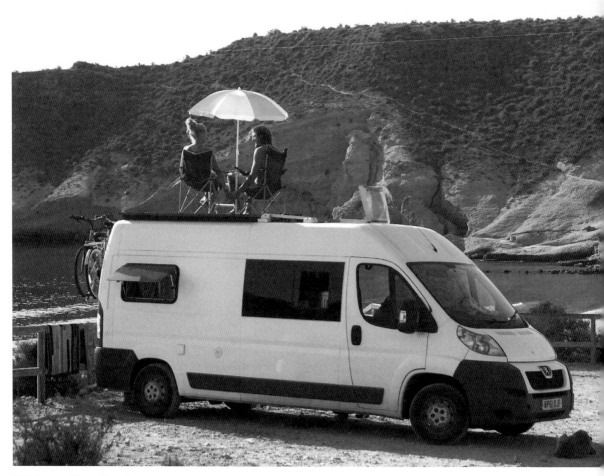

2011 Peugeot Boxer (Betsy)
Above: Northern Spain
Opposite: Biarritz, France
Contributed by Emma Walker

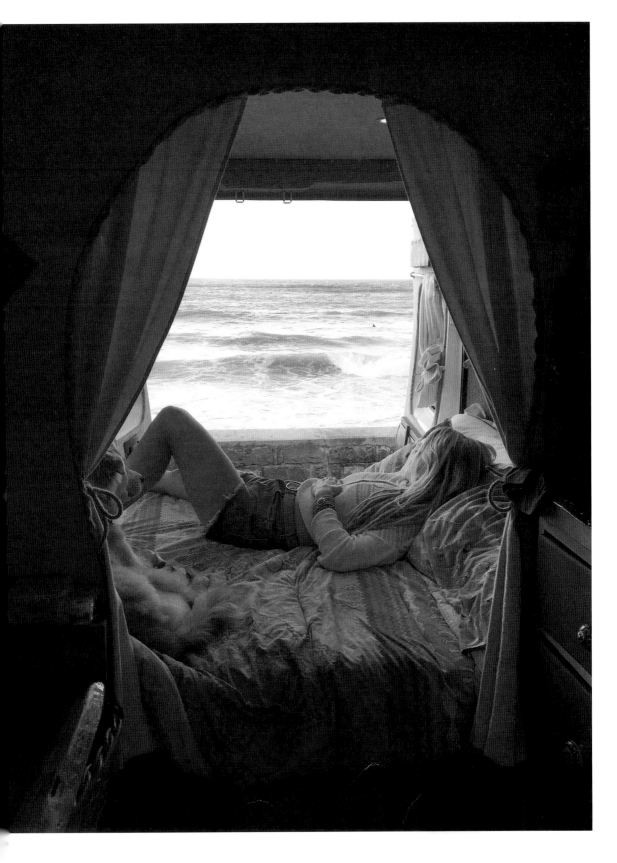

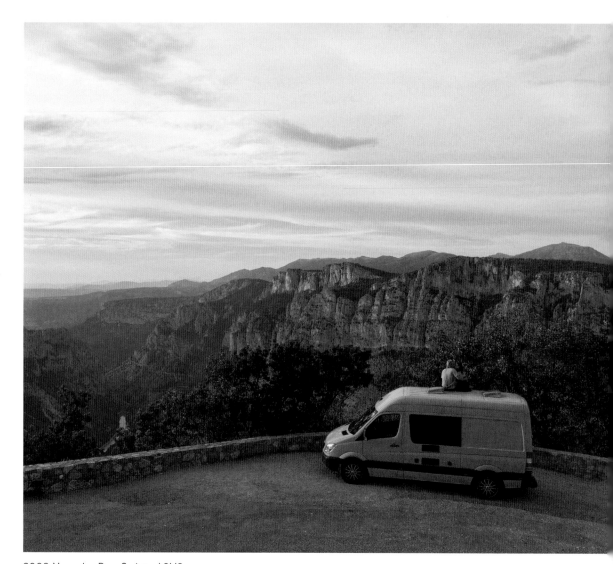

2008 Mercedes-Benz Sprinter L2H2
Above: Oetztal, Austria
Opposite: Wolfgang, Austria
Contributed by Jens Hruschka

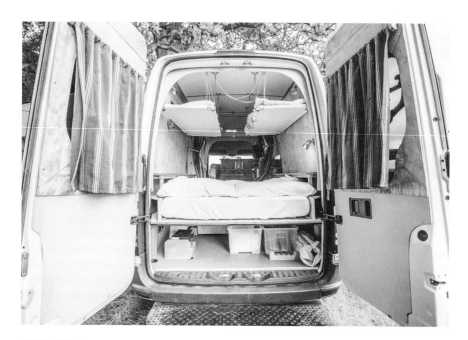

Mercedes Sprinter (The Bunkhouse Road-Tripper)
Herefordshire, England
Contributed by Bill Goddard

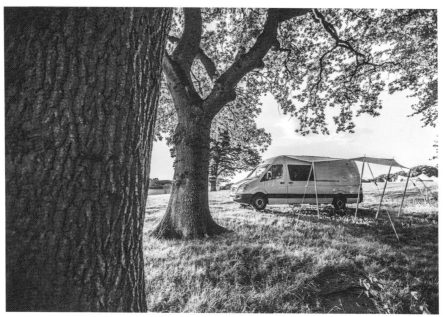

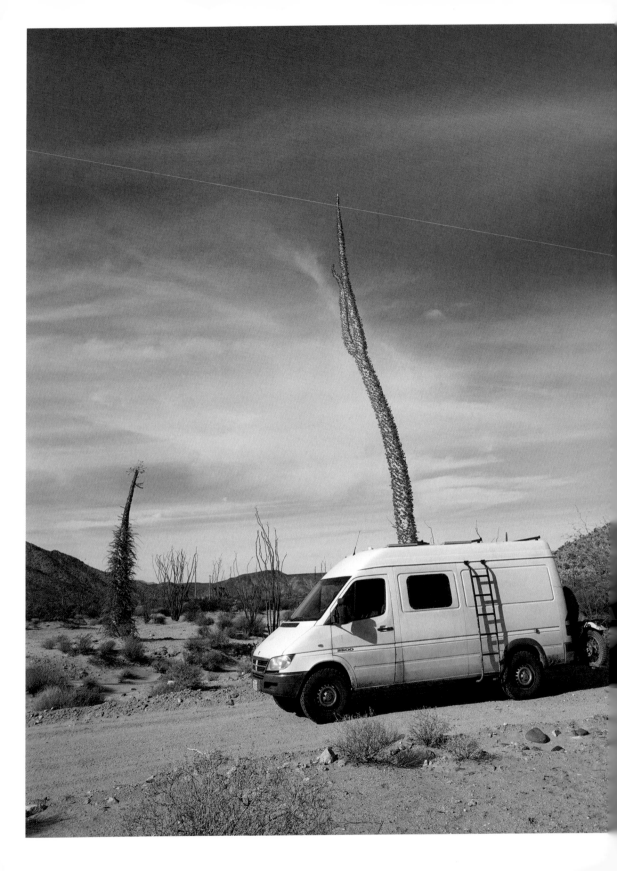

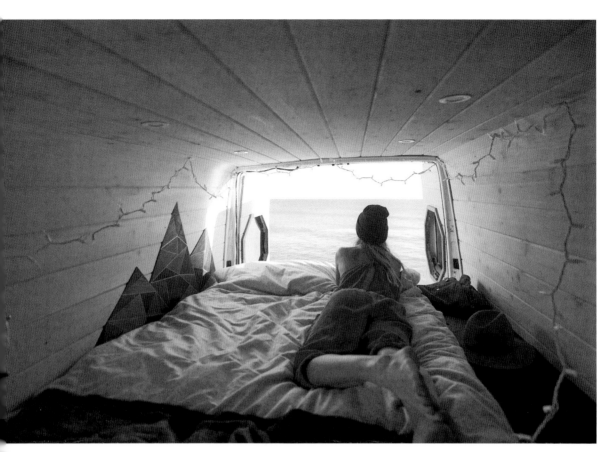

2005 Dodge Sprinter 2500
Above: Punta Colonet, Mexico
Left: Mammoth Lakes, California
Opposite: Bahia de los Angeles, Mexico
Contributed by Tommy Erst

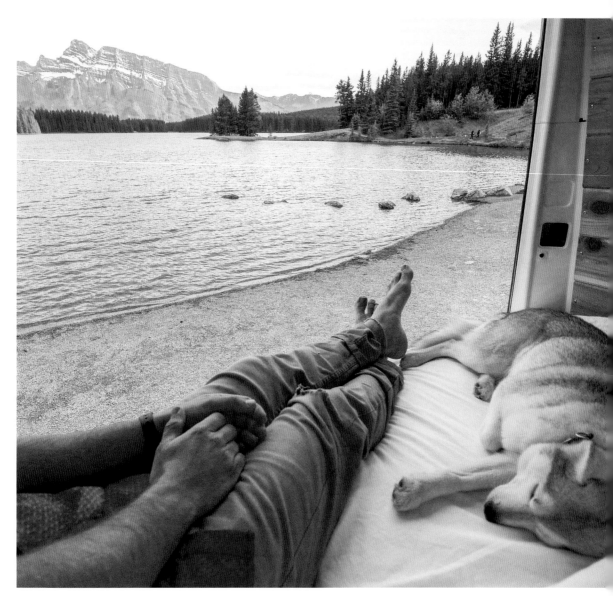

2003 Dodge Sprinter 2500
Above: Banff National Park, Alberta, Canada
Opposite top and bottom: Pacific City, Oregon
Contributed by Jace Carmichael

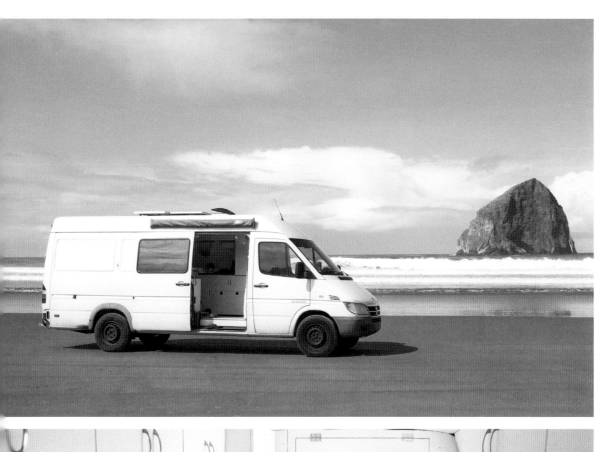
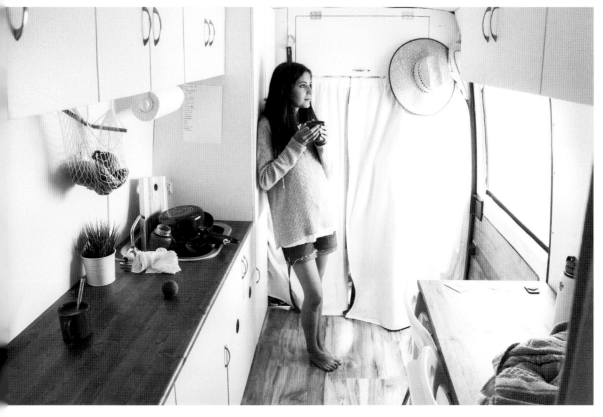

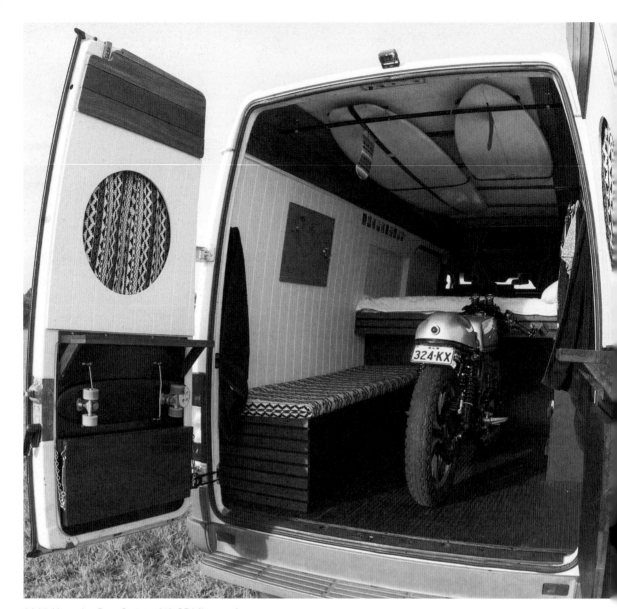

2005 Mercedes-Benz Sprinter 313 CDI (Lagopna)
Sunshine Coast, Queensland
Contributed by Beau van der Werf

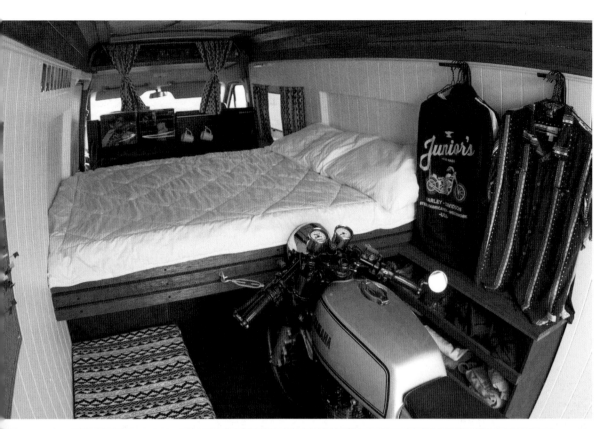
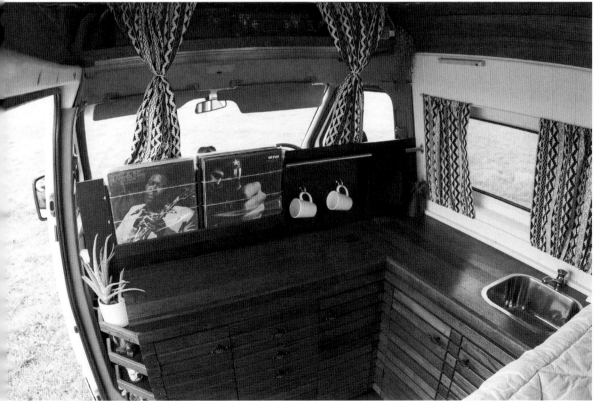

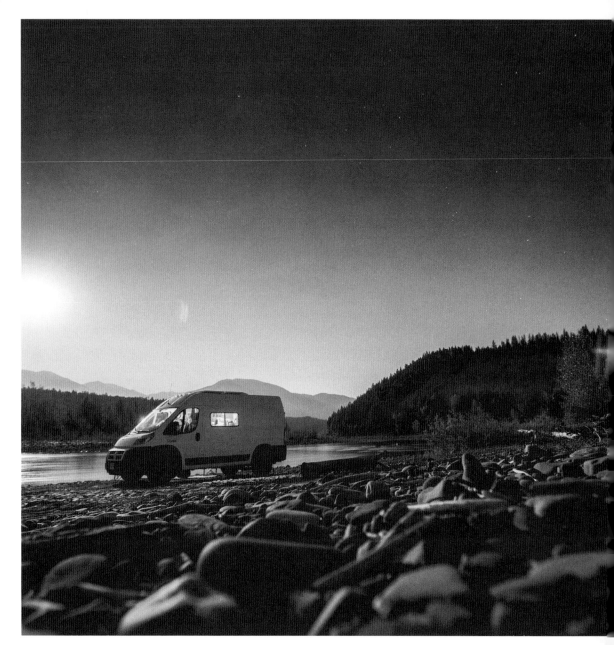

2016 RAM ProMaster
Above: Glacier National Park, Montana
Opposite: Jackson, Wyoming
Contributed by Thomas Woodson

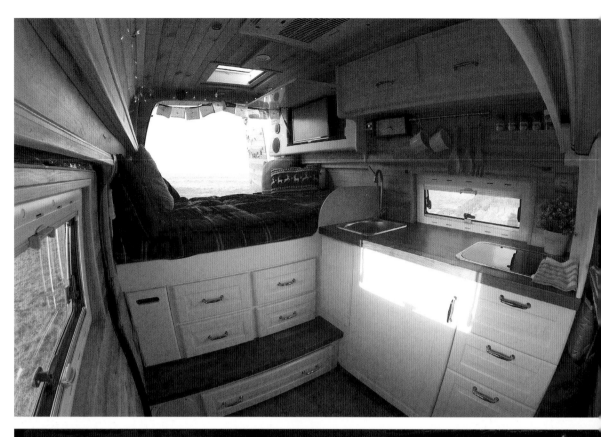

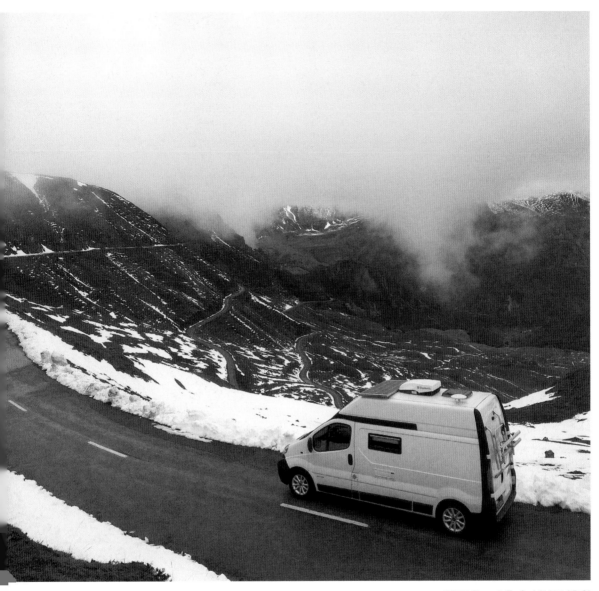

2003 Renault Trafic L2H2 1.9DCI
Above: Ubiñas Natural Park, Spain
Opposite top and bottom: Verdicio Beach, Spain
Contributed by Sergio Garcia Rodriguez

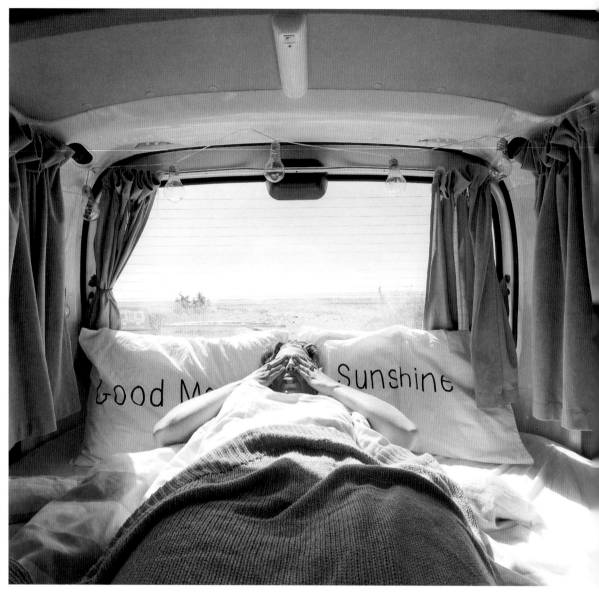

2002 Toyota Hiace Hi-Top Campervan (Hilda)
Above: Puponga New Zealand
Opposite top: Mount Cook, New Zealand
Opposite bottom: Waitaki, New Zealand
Contributed by Amy Nicholson

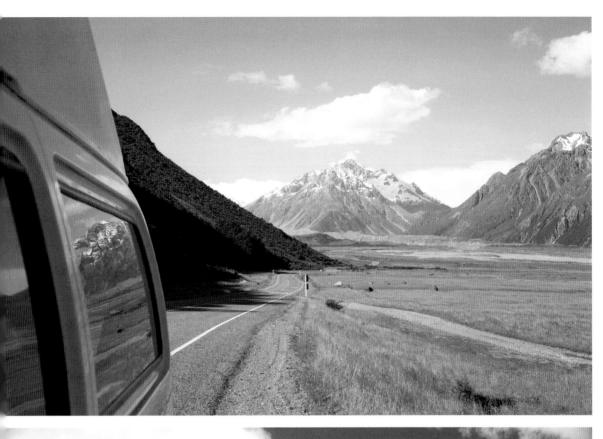

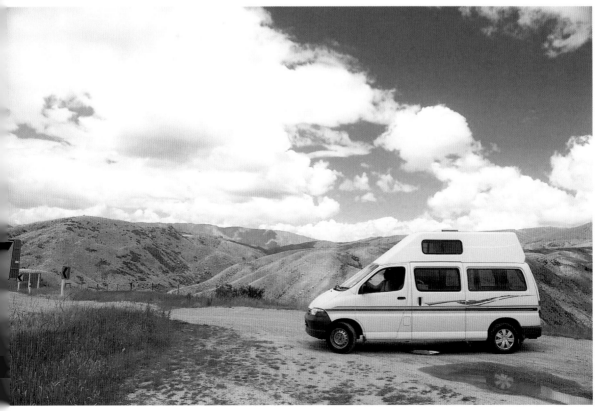

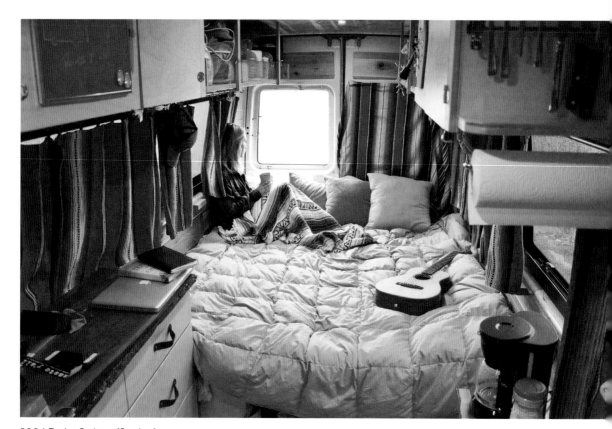

2004 Dodge Sprinter (Sonders)
Above: Asheville, North Carolina
Opposite top: Cocoa Beach, Florida
Opposite bottom: St. Augustine, Florida
Contributed by Taylor Bucher and Peter Thuli

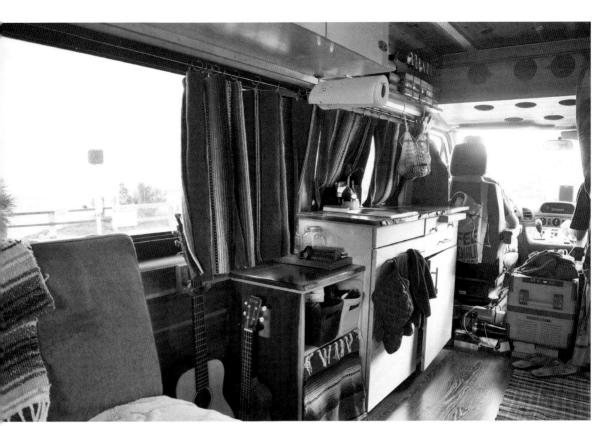

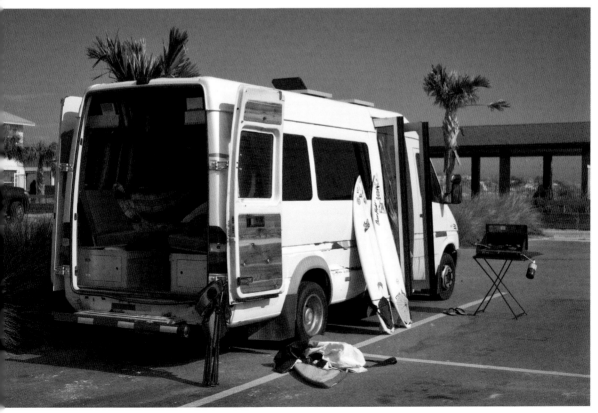

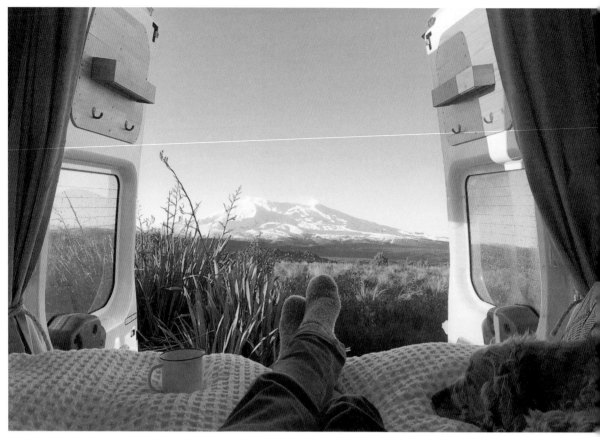

2008 Ford Transit (Rusty)

Above: Mount Ruapehu, Tongariro National Park, New Zealand

Right: Piha, Auckland, New Zealand

Opposite top: Havelock North, Hawkes Bay, New Zealand

Opposite bottom: Waimarama Beach, Hawkes Bay, New Zealand

Contributed by Jonathan Edward Johnston

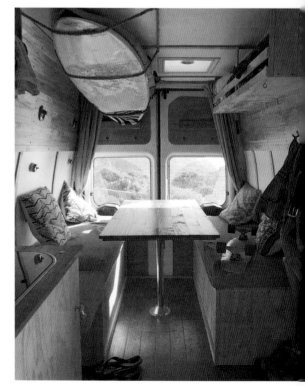

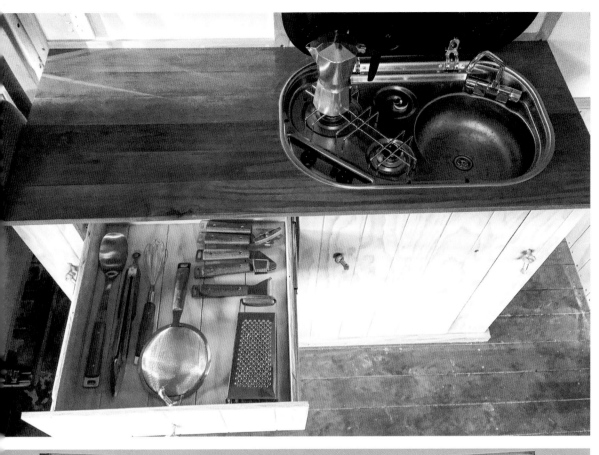

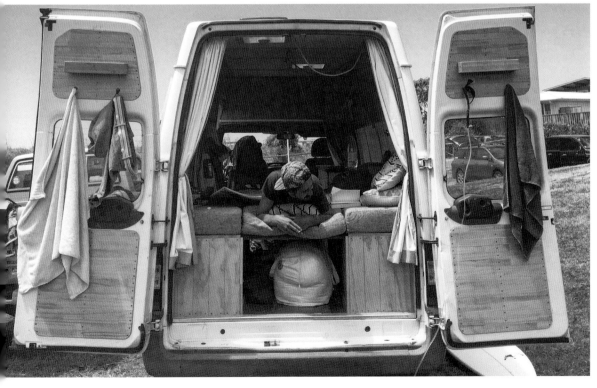

CHAPTER 4

AMERICAN VANS

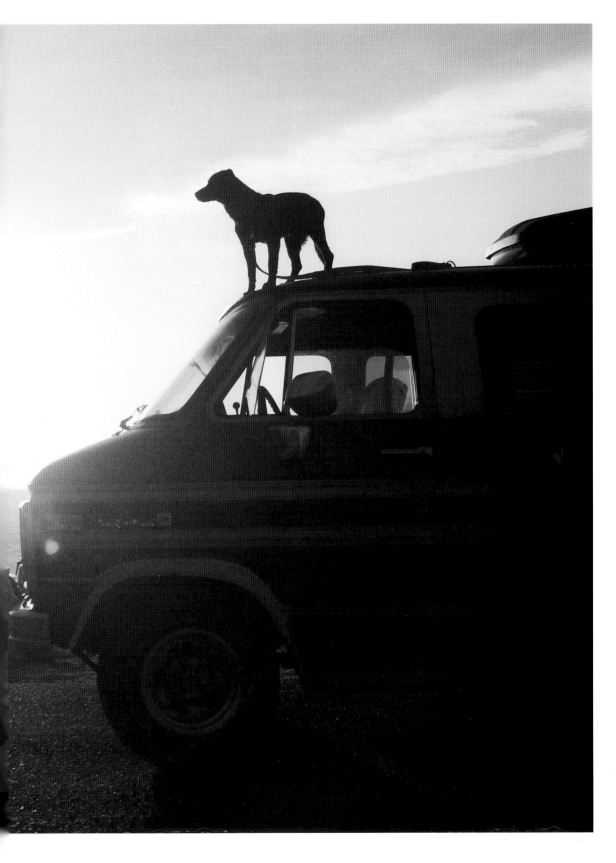

Previous page:
1985 GMC G2500
Vandura 5.0 L V8 (Van)
Cape Perpetua, Oregon
Contributed by Michael CB
Stevens

Clockwise from the left:
Owens River Valley,
California; Alabama Hills,
California; Santa Barbara,
California

Searching the great unknown: College student Sean Collier discovers that his GMC Vandura is the key to unlocking a creative future.

I often look back and wonder why I waited so long to buy a van. Why wasn't my first car in high school a van? Why didn't I scrape together some savings and buy one in college? It would have undoubtedly changed the course of my life and led to some amazing experiences and trips in my teens and early twenties. It's good to remember that your first van doesn't have to be a rare VW or a super-dialed-in camper. Your van is what you make it, and it could be anything—a compact truck, a minivan, or just your standard Made-in-the-USA van. That's what surfer, photographer, and traveler Sean Collier rolls in. He's a college student from Santa Barbara, California, and we had a chat about his 1995 GMC Vandura.

FOSTER: What type of van do you have? What made you want to buy a van and how did you find it?

SEAN: My van is a 1995 GMC Vandura, one of their Explorer models. After seeing so many photos of sweet VW rigs for years, I went on the search to find a van of my own. I remember staying up late on craigslist and on the Samba [a VW enthusiasts' site], trying to find one that would be realistic and fit my needs as a young kid in high school. But the van fell into my possession in a different way. My mom is an AAA insurance agent, and had an old guy come in one day to insure his vehicles. He mentioned he was trying to get rid of an old van he never used anymore, so my mom told him that I might be interested. The next day I lit out of Santa Barbara and headed toward LA with a cashier's check in my glove box. It was love at first sight, and I snagged this rig with low mileage and for dirt cheap. These are those kind of vans that big families used to cross the country back in the nineties. It came fully equipped with a television set and Nintendo 64. Knowing that I probably wouldn't spend too much time gaming while on the road, I took that out to make room for storage.

FOSTER: What is the interior like? Have you done a custom build-out?

SEAN: The inside of the van is huge, and has potential to do some crazy build-outs in. But because the van came in great condition and has a fold-down bed, I didn't invest too much money or time in converting it, save for a kitchen space, custom roof racks for my surfboards, and plenty of room for guests. Some friends and I once were on a surf trip, and due to cold temperatures outside the four of us ended up all sleeping inside the van, plus six surfboards. I sleep, cook, and occasionally host movie nights inside the van. As time passes, I think up ideas of custom converting the inside to make it feel more homey, which I may want to start this summer.

Alabama Hills, California

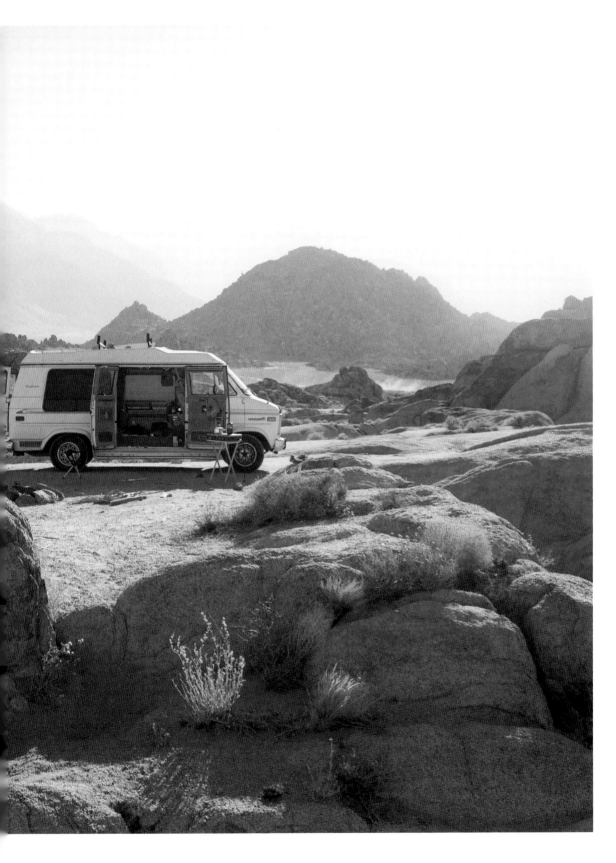

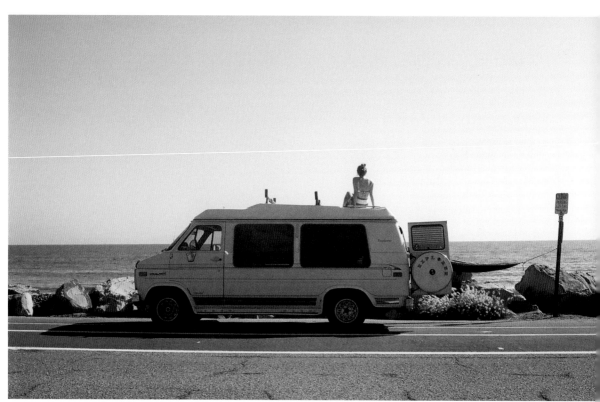

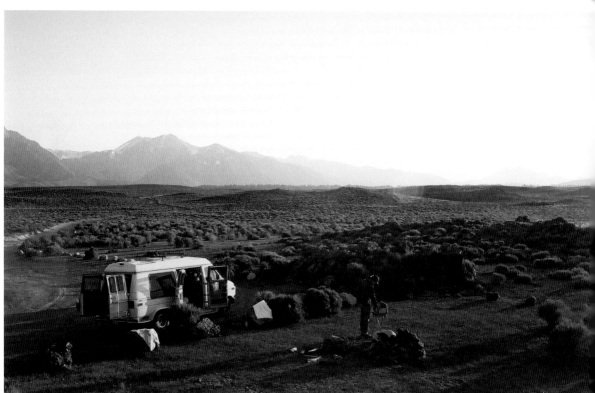

Top: Ventura, California; *bottom*: Owens River Valley, California

FOSTER: Do you ever stealth camp in it? How does that play out?

SEAN: This van is perfect for stealth camping, which I find myself having to do pretty frequently. It has solid curtains that I pull down at night when sleeping in neighborhoods or beachside parking lots. Because it is a pretty average-looking van without a pop-top, it makes for great stealth camping. I've only been hassled by a cop once, and he just asked me to find somewhere else to go.

FOSTER: What was the first trip you took it on? How did the van run?

SEAN: When I first got the van, I was so stoked that I would just drive a few minutes close to home and sleep in it at the beach. The first trip I took it on was a surf mission to Big Sur with a few friends, and this is when I quickly fell in love with staying in my van. I love getting off the pavement, too. This hog can handle some pretty serious dirt roads. It's trucked through a ton of back roads in the mountains of the Los Padres National Forest near Santa Barbara, California, and my favorite place of all, the Eastern Sierra mountains.

I quickly fell in love with staying in my van.

FOSTER: Is the van pretty reliable? Any major breakdowns while on the road?

SEAN: Fortunately, the van hasn't had any major breakdowns while on the road in the three years that I've owned it. I continuously work on it and make adjustments as it ages, but I've been lucky enough not to have to spend a ton of money at the mechanic. I work on it myself with the help of a good friend.

FOSTER: Anything you would change about the van?

SEAN: Something I would probably change—like every other van owner—is its gas mileage. The thing is a gas hog, and sometimes makes me have to rethink trip plans based on financial circumstances. But hey, that's van life.

FOSTER: What does your future look like now that you have this van?

SEAN: Unfortunately, I'm still finishing up college in Santa Barbara, traveling and taking photos in my spare time. I graduate next May, and I'm planning on taking time off, moving into the van, and exploring the States (don't tell my mom). I just don't think I'm ready to take a full-time job on yet. There's too much out there that I want to see.

FOSTER: What might be your favorite memory or event since owning the van?

SEAN: My favorite part about owning a van is the opportunity it brings to meet new people and make memories with good friends. I've been lucky enough to meet strangers on the road that choose to live the same sort of lifestyle, strangers that I now call close friends. There's definitely a community forming around the van life culture, a bunch of dirtbags that just want to be outdoors and do rad things. Cruising around and sleeping in our vans allows us to do that.

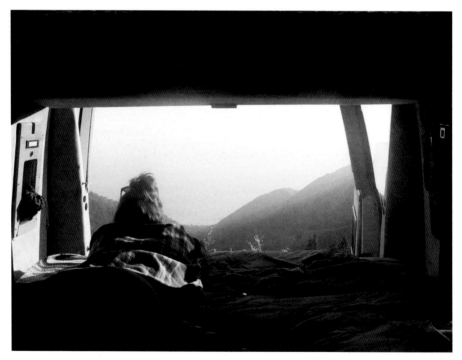

Big Sur, Calfornia

Opposite: 1969 Dodge A108 (Irwin)
Ocean Park, Washington
Contributed by Mary and Joel Schroeder

American Vans Archive

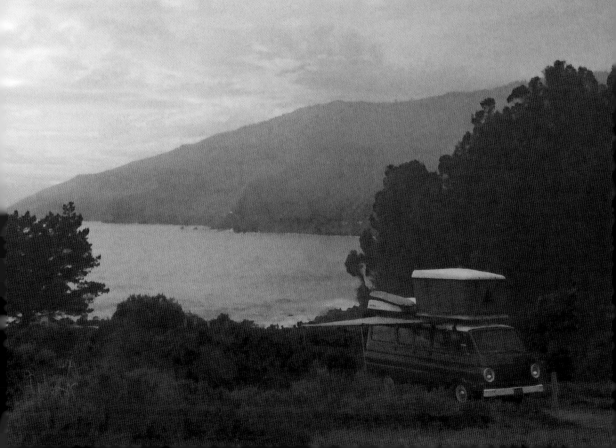

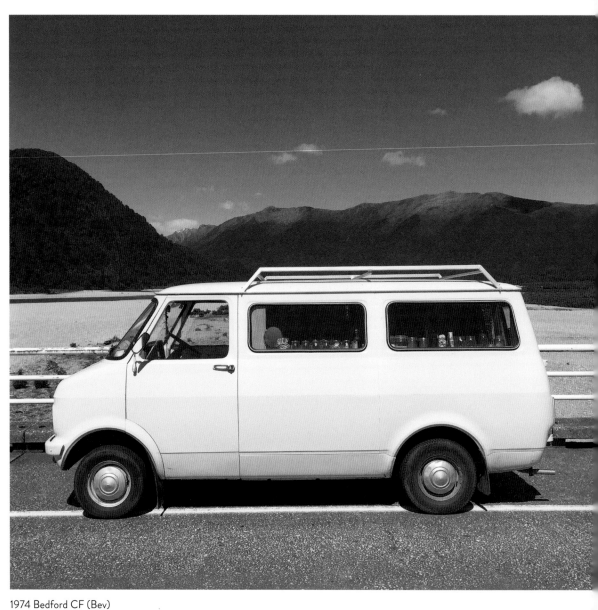

1974 Bedford CF (Bev)
St. Andrews, Canterbury, New Zealand
Contributed by Capucine Couty

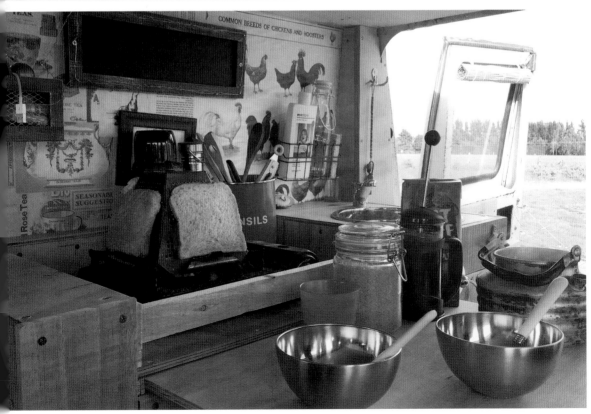

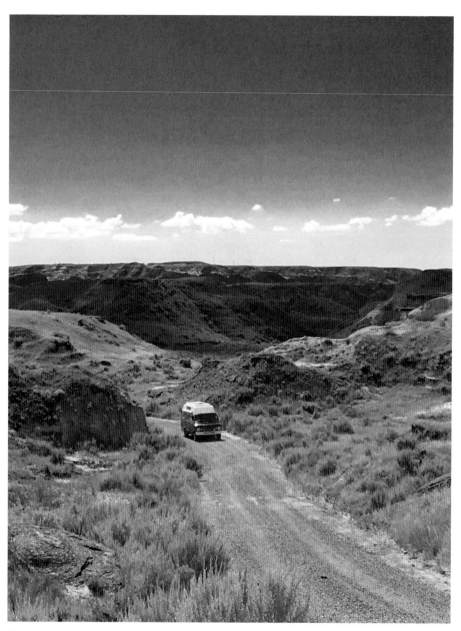

1976 Dodge Tradesman 200 (Free Monkey)
Dinosaur Provincial Park, Alberta, Canada
Contributed by Tiphaine Euvrard

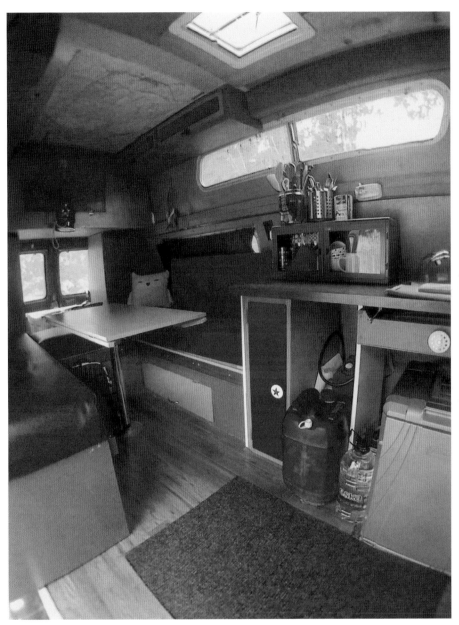

1976 Dodge Tradesman 200 (Free Monkey)
Quebec, Canada
Contributed by Tiphaine Euvrard

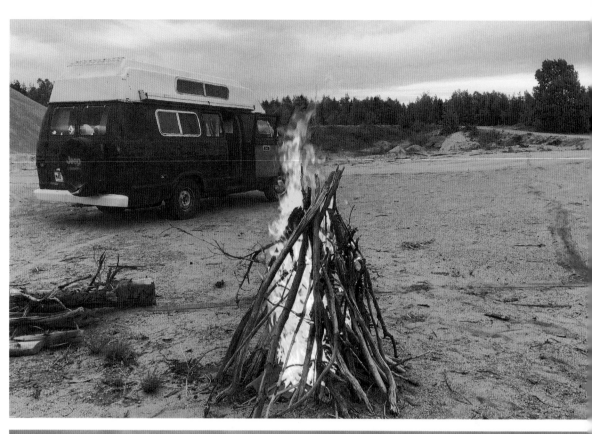

1976 Dodge Tradesman 200 (Free Monkey)
Quebec, Canada
Contributed by Tiphaine Euvrard

1994 Ford E-150
Malibu, California
Contributed by Brian Peck

Opposite:
1996 Ford Econoline (The Struggle Bus)
Arches National Park, Utah
Contributed by Grant Koontz

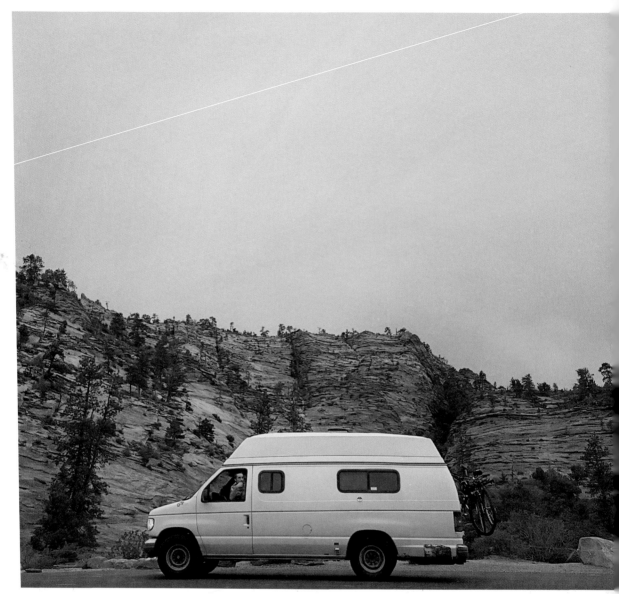

1995 Ford Sportsmobile (Tatanka the White Buffalo)
Above: Zion National Park, Utah
Opposite top: Capitol Reef National Park, Utah
Opposite bottom: Pacific Coast Highway, California
Contributed by Jane Salee and Casey Siers

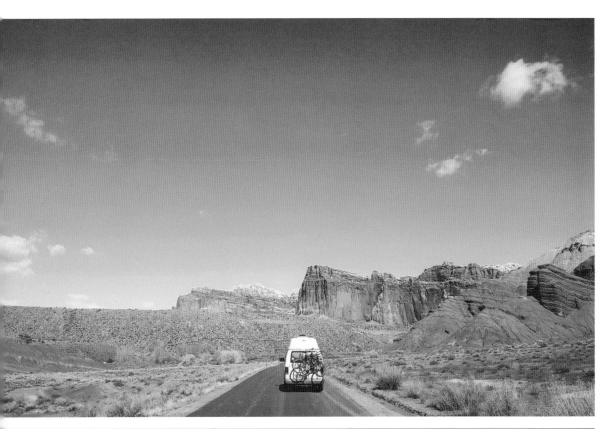

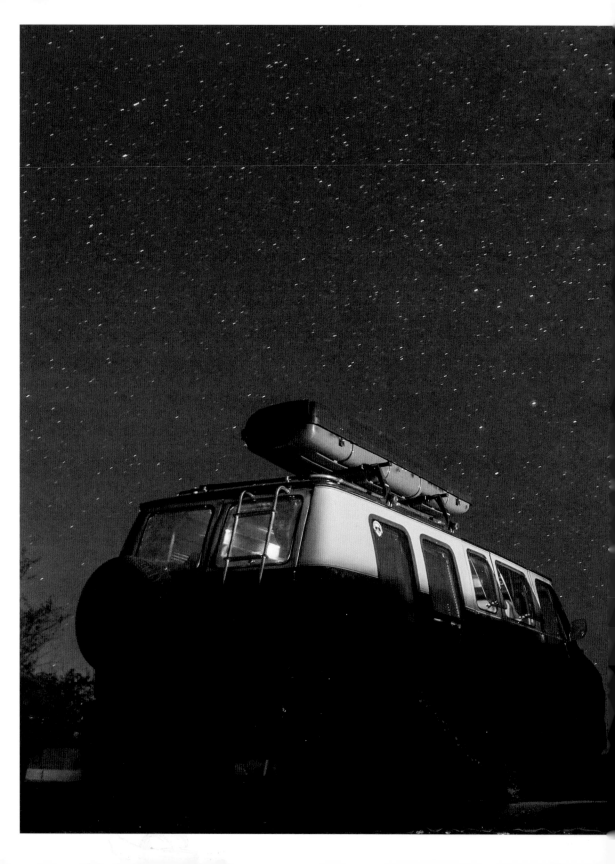

1985 GMC G2500
Vandura 5.0 L V8 (Van)
Oregon Coast
Contributed by
Michael CB Stevens

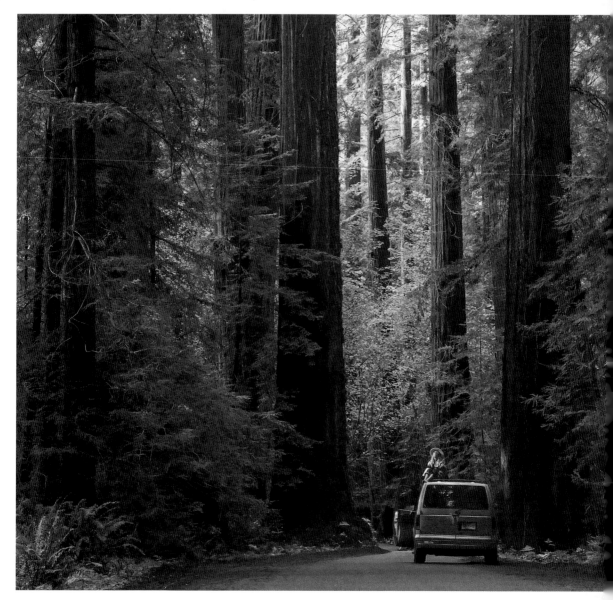

2002 Chevrolet Astro (Freedom Van)
Garberville, California
Contributed by Rachel Leah Burt

2002 Ford E-350 (Pork Chop)
Opposite top: San Simeon, California
Opposite bottom: Yosemite National Park, California
Contributed by Ross Nicol

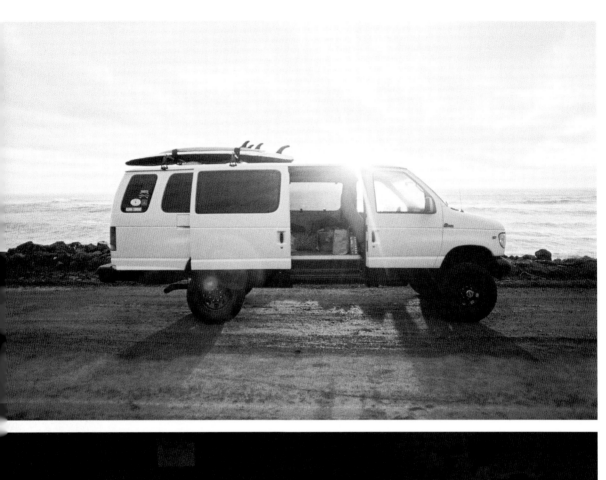
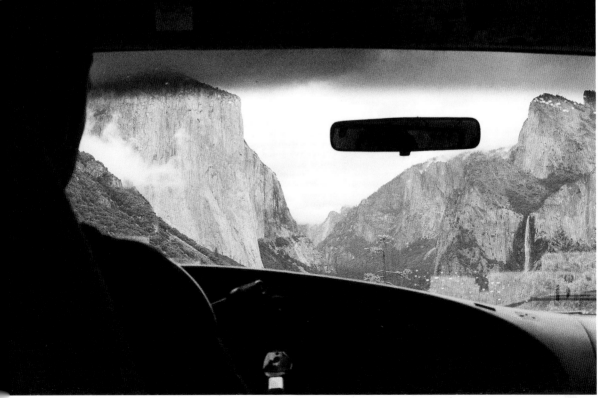

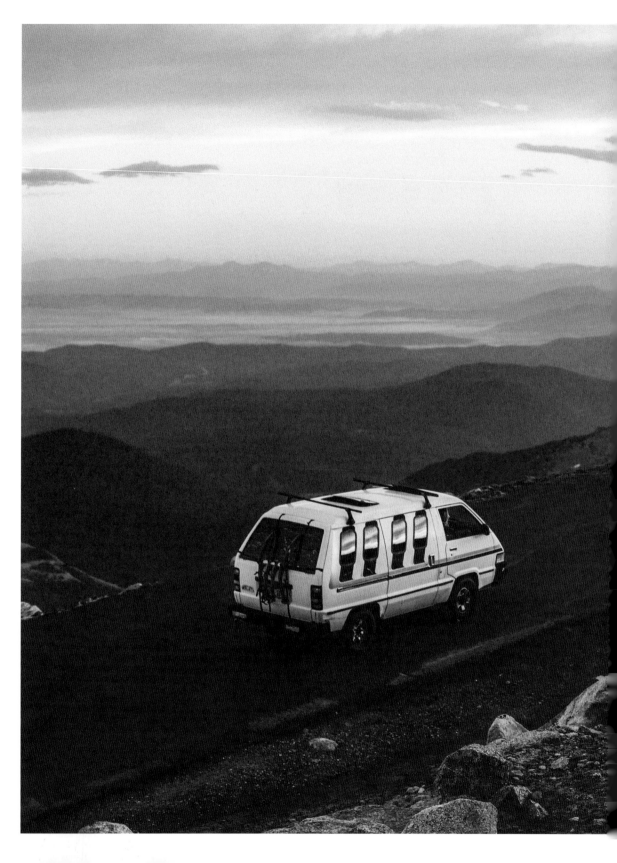

CHAPTER 5

JAPANESE VANS

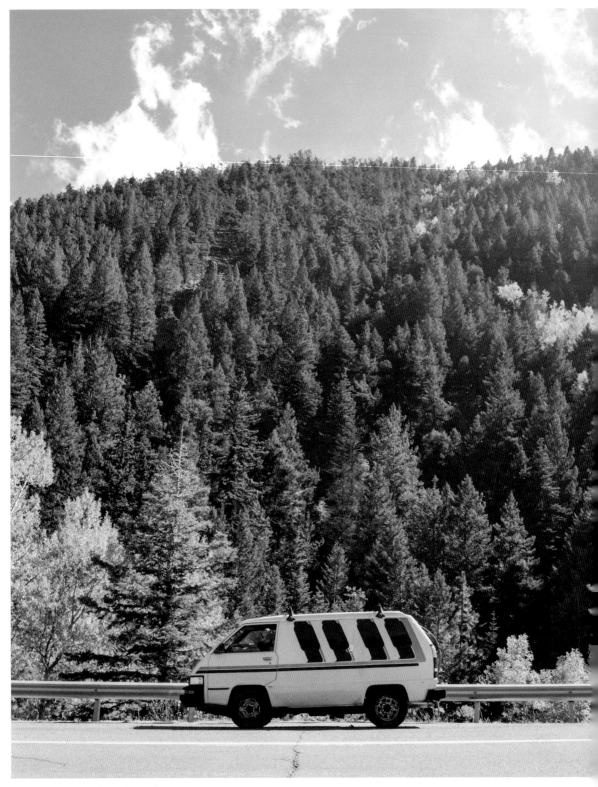

Hardscrabble Pass, Colorado

Previous page: 1987 Toyota Van (Right Lane Rhino), Evergreen, Colorado; contributed by Marianne Brown

The gift that keeps giving: Kathleen and Greg's inherited 4x4 Toyota Van is in it for the long haul.

If I were to buy a van on a budget of say, five to seven thousand dollars, the first vehicle I'd start searching for is an '80s Toyota Van. They are reliable, compact, fuel efficient, and come in a true 4x4 option. Like VW vans, they make the most of their wheelbase, with the cockpit built directly over the front wheels. This maximizes usable interior space and gives the driver a great vantage point on the highway. Kathleen, Greg, and their two dogs, Blaize and Peaches, travel and live in one of these sought-after Toyota Vans and are currently in the final stages of building it out in preparation for an upcoming adventure.

FOSTER: What is the make and model of your camper?

KATHLEEN: We own a 1987 Toyota Van. In Japan, the model is called the Space Cruiser, but, in America, it is simply called a Van or a Van Wagon.

FOSTER: How did you decide on a Toyota Van?

KATHLEEN: We knew we wanted a Toyota 4x4 and were leaning toward a Tacoma with a topper and build-out. We still think a Tacoma would be a great rig, but when we saw the Van, we knew it was just what we wanted and the price was right. It's four-wheel drive and has airplane-style windows, giving it a persona that was hard to resist.

FOSTER: How does it compare to other vehicles that you've owned in the past?

KATHLEEN: Greg had lived in two separate Toyota vans in New Zealand and was familiar with their longevity. He was also aware of their underpowered nature and propensity for overheating. These familiarities gave him the patience and gentle touch in driving and caring for our Van. Along the way, I've learned the personality of our Van so that I can take it out on my own.

We find similarities in our Van with a 1997 Jetta GLX in the sense that they were both "designed for drivers." It felt like we had a relationship with them. So many moments shared together. When you have a connection with your rig, you take care of it and it takes on a life of its own.

FOSTER: How did you find it? What's the story? These are rare and cherished vans in North America.

KATHLEEN: Truthfully, the Van found us. After we'd lived in a camper trailer in a family's backyard for over a year, they gave us their Van as a farewell gift. It was likely bound for the scrap yard, as many

Arapaho National Forest, Colorado

people were not interested in fixing it up and giving it a second life. It was free under the condition that we keep the Van going. We ended up buying our own land and moving the camper there, taking the Van with us as well.

FOSTER: How did you modify it for living?

KATHLEEN: We modified our rig to be a four-season home on wheels. We went full-on with the insulation by adding a layer of radiant barrier, a layer of two-inch Styrofoam insulation, and a second layer of radiant barrier sealed with tuck tape—all of which was covered with rough-cut cedar paneling. To insulate on this level, we needed to build a box inside a box, meaning that we had to craft three separate doors: one door between the cockpit and the sleeping area, a door inside the sliding door, and a door inside the back lift gate. We added an 80-watt solar panel on top of a 21-cubic-foot Thule box. We added taller, more narrow tires that give the Van an extra inch of clearance while also making it more fuel efficient and capable in the snow.

We always take our two dogs, Blaize and Peaches, with us on our road trips.

FOSTER: How did you build out the sleeping setup? How many people can travel in it? Do you travel with any nonhuman friends?

KATHLEEN: When we received the Van, it had two bench seats that folded down to make a bed. We were able to take it on trips and sleep in the back, but often not very comfortably. We decided to take out those seats and make our own build-out.

We designed our space so we can put our middle bench seat in if we need it. That would allow four people to travel with seat belts. We went with a full-sized trifold bed that will act as a bench when we're not using it. When we're ready to sleep, we pull it out and it takes up the entire back area of the Van.

We always take our two dogs, Blaize and Peaches, with us on our road trips. We created an area behind the front seats for their dog beds so that they can travel comfortably, see us and the action on the road.

Grant, Colorado

FOSTER: How does the Van handle on gravel roads?

KATHLEEN: This van is amazing for light to medium four-wheeling. It won't go all places, but it can go most. We've unexpectedly encountered fairly technical four-wheeling trails and have been pleasantly surprised with its off-road capabilities.

FOSTER: What is the most memorable trip that you've taken it on?

KATHLEEN: Greg's favorite memory is cruising through the National Forest surrounding Lost Creek Wilderness area in Colorado on a beautiful fall afternoon. The four-wheeling wasn't too technical, but just hard enough to make it less crowded than most areas. We took the Van on a back road to a trailhead and left it behind while we backpacked in and returned the following morning.

The most memorable moment for me was four-wheeling in Colorado's Arapaho National Forest with our friends. We were following our friend with his two children in their Ford F-150 down some back roads to do some exploring. We got to an area in the road that was too technical and his truck started sliding down the mountain. He was able to steer it straight down the mountain and, luckily, picked up the same trail at the bottom. It was quite scary, especially knowing his children were in the truck with him. We also felt helpless as we watched from our Van. But his quick thinking got him back on track.

FOSTER: What would you recommend to someone interested in building out a small van? What would you change about your camper?

KATHLEEN: It's important to insulate to your comfort level and choose materials that won't mold or rot. Space is tight, but

Arapaho National Forest, Colorado

you will almost never be disappointed you have too much insulation in the summer or wintertime.

Access to our engine is below the driver's seat, which means we had to design our build to allow the seat to fold back into our living space in order to get to the motor. The motor itself is reliable but underpowered, as it was originally designed to be a forklift motor. If it were practical, we would increase airflow to the engine and build out a larger radiator. Unfortunately, it's just a built-in mechanism, but it helps remind us to slow down and take breaks along the road.

FOSTER: Any advice for someone looking to downsize to living in a van?

KATHLEEN: Remember that you're building your van to live out of it instead of in it. Choose the adventure that fits your lifestyle and let the rig follow. While your adventuremobile will play a big role in your travels, the time you spend out of it is even more valuable.

A smaller rig is easier to navigate both in cities and off-road. We have found that most experienced van lifers wish they had chosen a smaller rig, and we would agree that it's easier to work with a smaller space. We don't have issues finding parking or stealth camping in a big city.

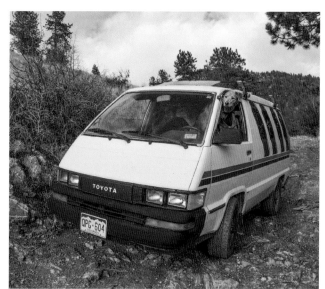

Arapaho National Forest, Colorado

Opposite:
Toyota Previa
Baja California, Mexico
Contributed by Foster Huntington

Japanese
Vans
Archive

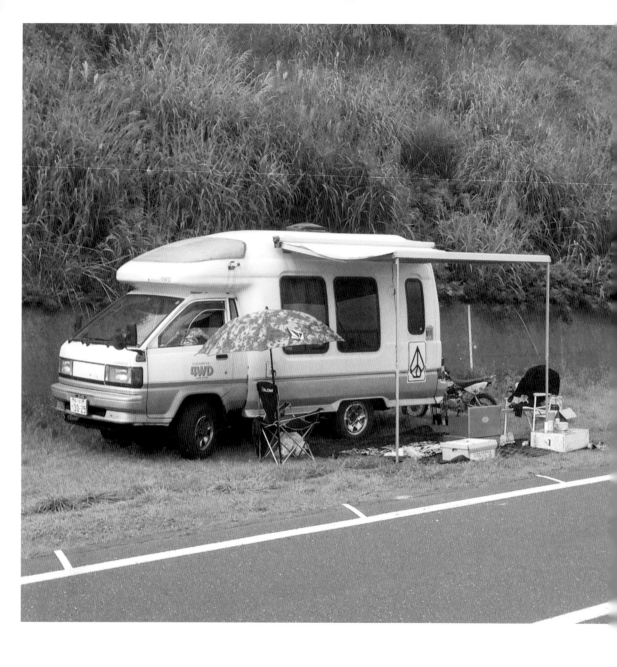

1991 Toyota Lite Ace Camping
Above: Asahidake, Hokkaido, Japan
Opposite: Haboro City, Hokkaido, Japan
Contributed by Hayato Doi

1990 Mitsubishi Delica
(Gwenn)
Lake Pukaki, New Zealand
Contributed by Lara Edington

1984 Toyota Van (The Dream Journey)
Humboldt Redwoods State Park, California
Contributed by Ian Harris

1987 Toyota Van (Right Lane Rhino)
Evergreen, Colorado
Contributed by Marianne Brown

1996 Daihatsu Hijet
Left: Mülheim an der Ruhr,
Germany
Above: Ajo, Spain
Opposite: Fumay, France
Contributed by Daniel Kalinowski

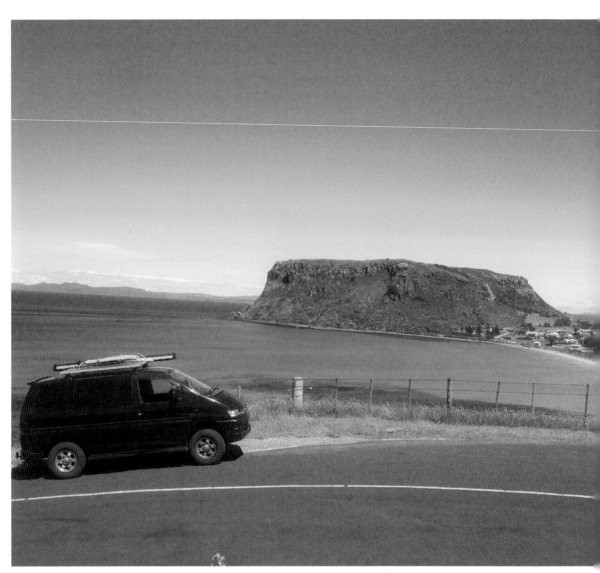

1999 Mitsubishi Delica Spacegear (Ziggy)
Stanley, Tasmania
Contributed by Julia Vasilevskaya

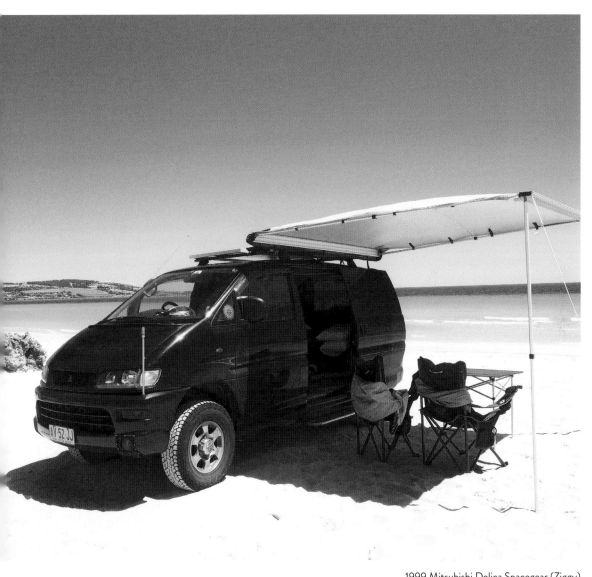

1999 Mitsubishi Delica Spacegear (Ziggy)
Emu Bay, Kangaroo Island, South Australia
Contributed by Julia Vasilevskaya

CHAPTER 6

SCHOOL BUSES

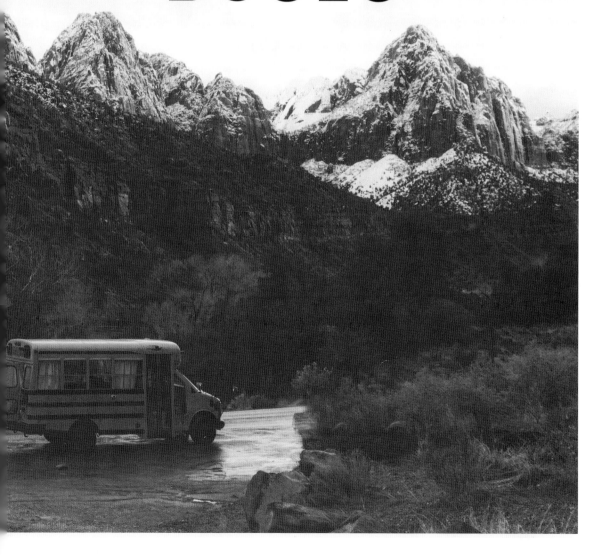

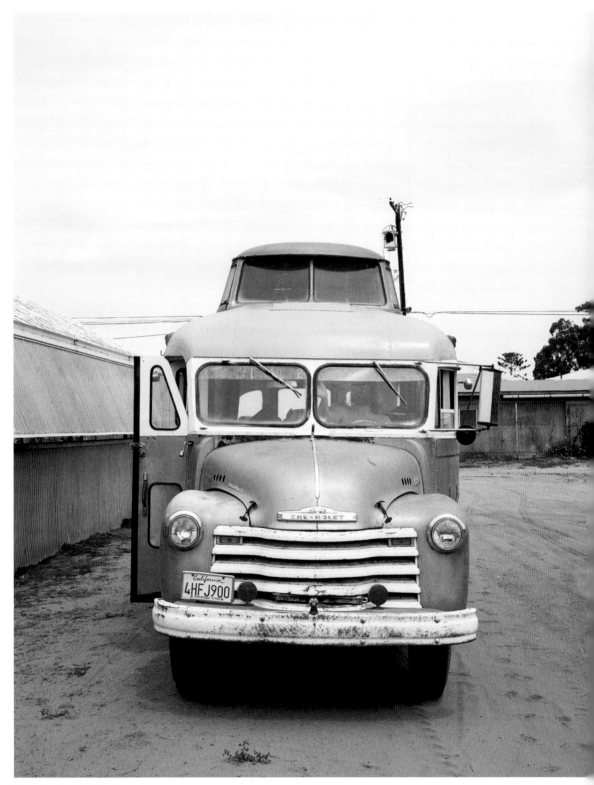

Santa Barbara, California
Previous page: 2000 GMC Bluebird Mini (Sasquatch), Big Water, Utah; contributed by David Waugh

Back from The Dead: Maverick board shaper Ryan Lovelace's converted school bus finds a permanent home on the Central Coast of California.

Sometimes the van gods smile down on you and a mysterious craigslist posting changes the course of your life forever. I met board shaper Ryan Lovelace five years ago down in Santa Barbara. I was blown away not only by the boards he was making but even more by the home he was living in, the Cosmic Collider—a 1948 Chevy bus with a VW van body and custom-built sleeping loft welded onto the top. It's unlike anything I've ever seen in my travels—a completely functioning home that is also a drivable work of art. Ryan is one of the most hilarious and hard-working guys I've ever known and his board designs are coveted by serious riders around the globe. He's got big ideas and, more importantly, he acts on them. I find his brilliant shaping work and his overall outlook on life to be fuel for action in my own life.

FOSTER: How did you find the "Cosmic Collider"?

RYAN: I was in Australia chilling on my buddy's couch and it was in the used cars section on craigslist. I think it said "school bus conversion." The pictures were horrible—I could barely make them out—but I thought, "If that's what I think it is, it must be mine." I emailed and called and couldn't get ahold of the owner, but then it came up on eBay for five thousand dollars, "Buy It Now." I borrowed half the money from my friend Mike. I think I finally convinced the seller to take thirty-six hundred dollars for it, and I drove it away.

FOSTER: So what's the make and year?

RYAN: It's 1948 Ford bus with a late '60s VW split-window bus frame welded to the top. I think maybe the Volkswagen is a '67.

He also informed me that there were spirits of The Dead's Dancing Bears in the bus.

FOSTER: So when you bought it, did the owner tell you about its history?

RYAN: He told me a number of things, including that it followed The Dead around for decades, I guess. He'd received some emails from different people that told him they'd seen the bus in their childhood at different shows. He said he bought it from a woman in San Luis Obispo who was going to make it into a mobile weed dispensary. He felt that he was doing his job guiding it to his final owner, not just letting it rust somewhere looking cool. He also informed me that there were spirits of The Dead's Dancing Bears in the bus.

FOSTER: Was he serious?

RYAN: He asked me, "How do you feel about spirits?" He said there were seven of them that lived in the bus. They help you find things when you lose them, and when the bus breaks they'll fix it for you. This definitely wasn't the case once I owned it. I think maybe they split once I got it. He also gave me a crystal that I am to charge on the dashboard and put next to the battery every time I start it. You know, for energy flow.

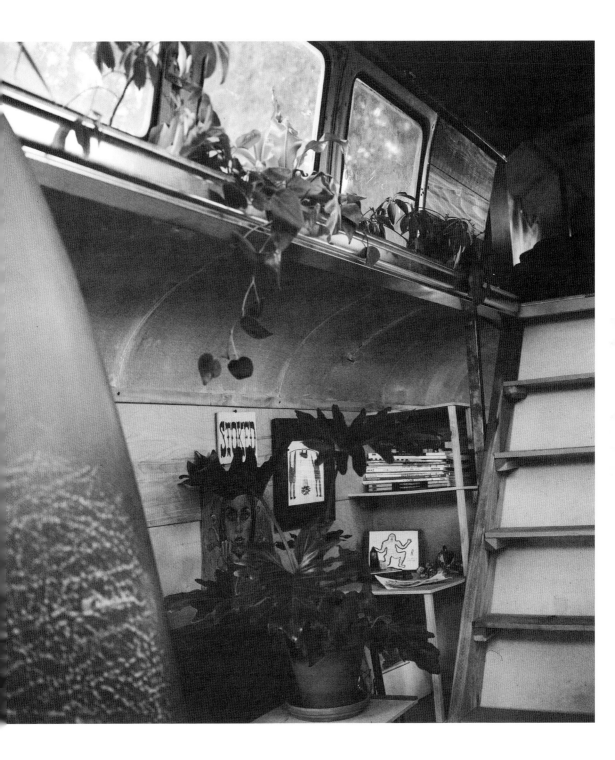

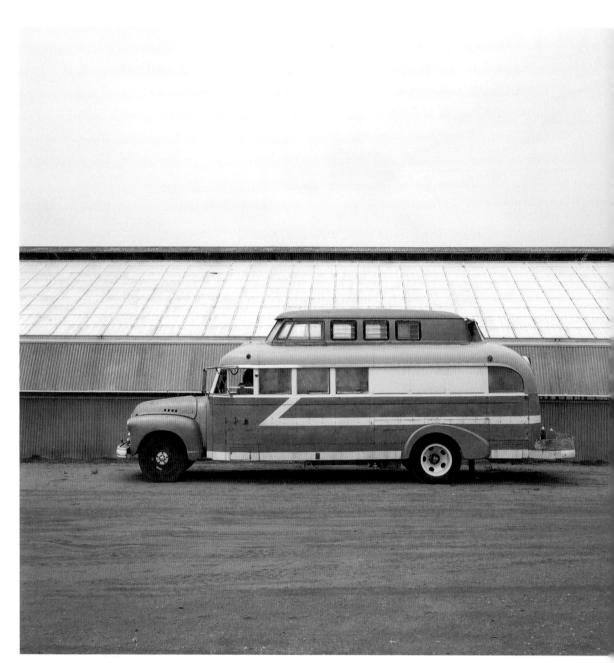

Previous page and above: Santa Barbara, California

FOSTER: Have you talked to him since?

RYAN: About a week after I bought the bus I gave him some crystals that I bought in Australia the week I found the bus—and no, it wasn't crystal meth. I told him, "Here, I want you to have these. They came into my possession when I saw the bus for the first time." And he was like, "No way! because I brought you crystals, too, that I was going to take from the bus, but I feel like they belong with the bus and need to stay there." So we had this, like, crystal handoff, and that felt more like the official "sale" of the bus than the actual exchange of money and the title.

I thought it was a way to retreat from society.

FOSTER: So when you bought it, were you always planning on living in it?

RYAN: Yeah, I thought it would be a really good way to shuck some responsibility. I thought it was a way to retreat from society. I didn't want to have to pay rent. I thought it was a solid move and knew it would help me build my board-shaping business. I also knew the bus was iconic and unmistakable, and I knew I could use it to my advantage.

FOSTER: How long did it take you to move in?

RYAN: I didn't touch it for about a year. I cleaned it out, but I had so many other projects going at the same time. I also knew it was a lifetime project. I wasn't going to smash through the work in five minutes. I started with the mechanical stuff in year one, but I didn't touch the inside until I had the mechanics safely working.

FOSTER: Did you feel like it was sacrilege to tear off the back of that VW van to build the loft?

RYAN: You know when you're holding the saw and you have a plan, it feels like you're about to murder something, but once you start cutting through the roof of a car it's pretty liberating.

FOSTER: It's a great build-out. How did you modify it for living?

RYAN: I built out the floor and the wall and bolted it all down. All the redwood I used is old-growth redwood from George Lucas's property. They were tearing down a guesthouse and they donated it to Habitat for Humanity, and I found it and bought it from them. And as far as the woodstove, it's way more woodstove than that thing needs...which is exactly what it needs.

FOSTER: Is there a place you've been dying to go in the bus?

RYAN: I've had an idea in my head for a while now. I'd love to drive the bus all the way up the West Coast on a surf trip from Southern California, through Seattle, Washington (where I'm from), and up into British Columbia, visiting friends along the way in Oregon, Northern California, and all that good stuff. It may be another ten years before I can pull it off, but I'll make it happen one day when the bus is in perfect health.

Santa Barbara, California

Opposite:
2000 GMC Bluebird
Mini (Sasquatch)
Big Water, Utah
Contributed by David Waugh

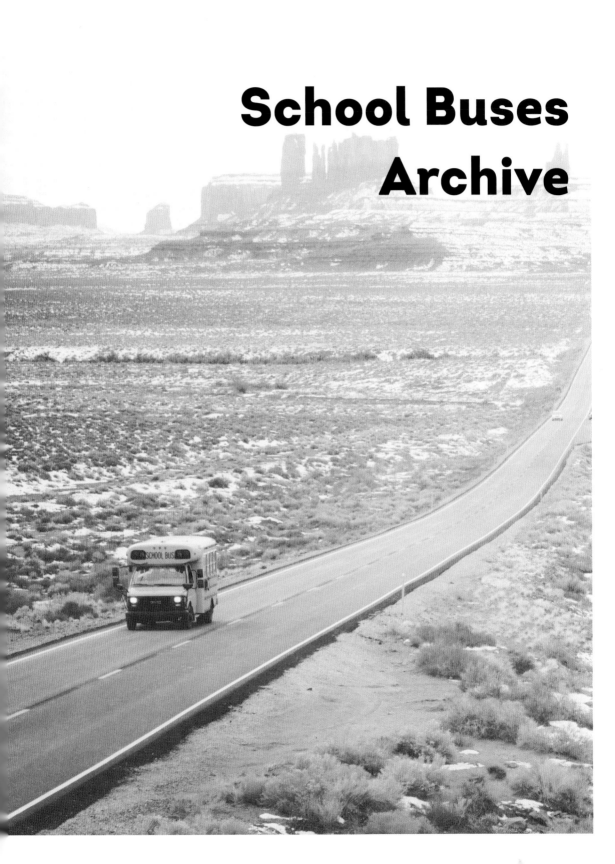

School Buses
Archive

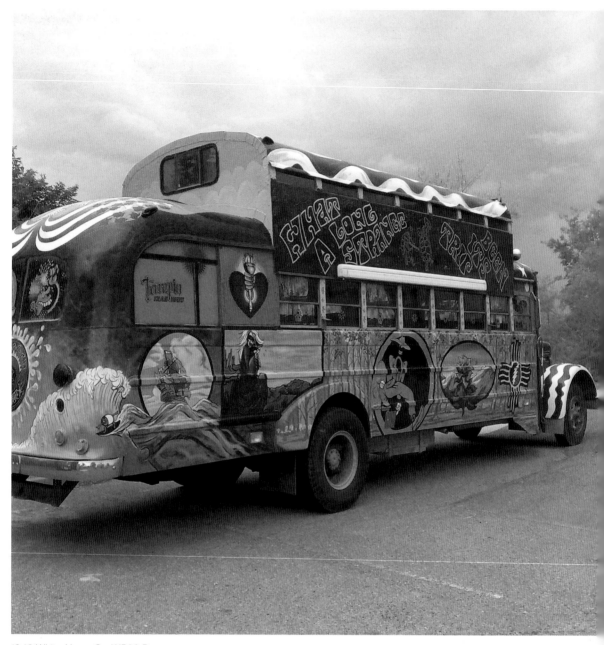

1948 White Motor Co. WB28 Bus
Rio Rancho, New Mexico
Contributed by Norm Ruth

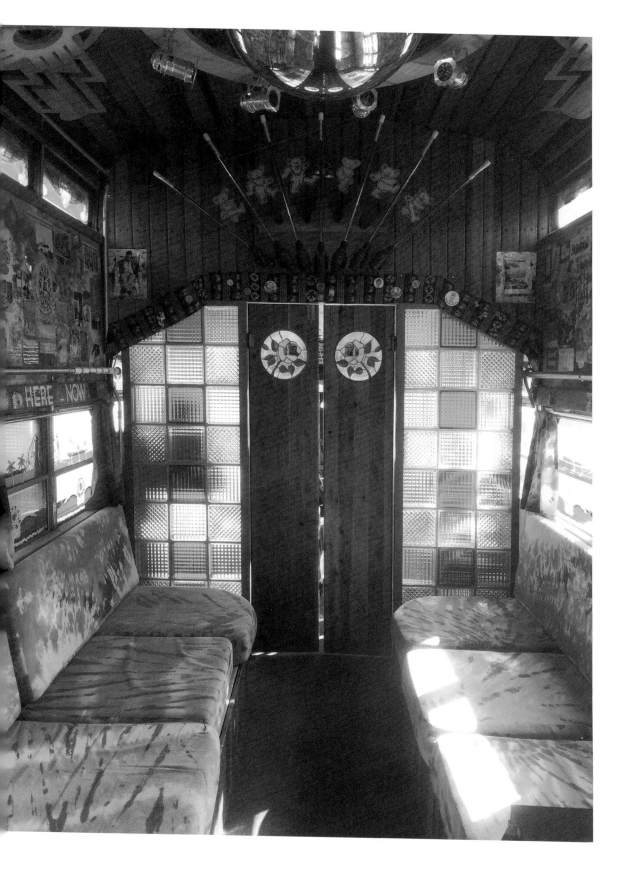

2000 GMC Bluebird Mini (Sasquatch)
Above and opposite: Big Water, Utah
Contributed by David Waugh

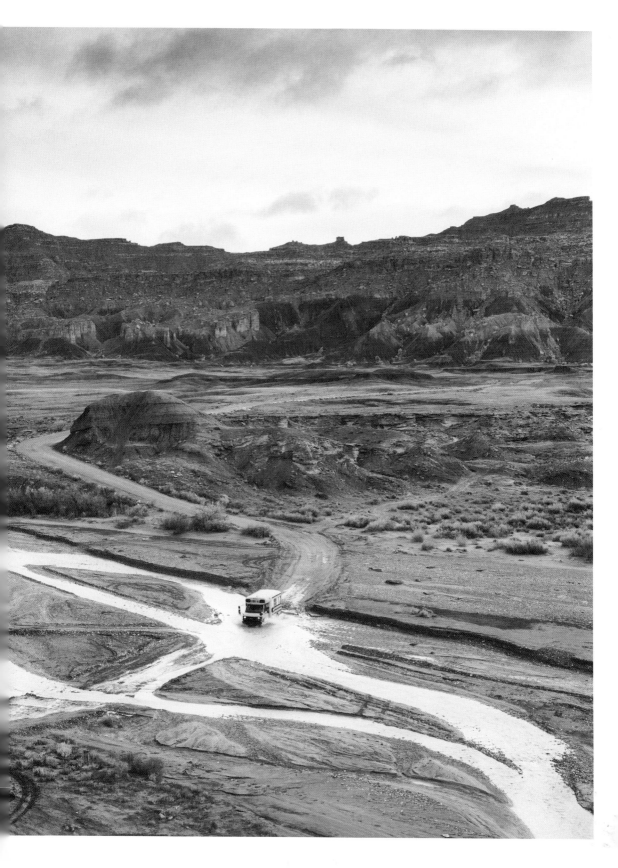

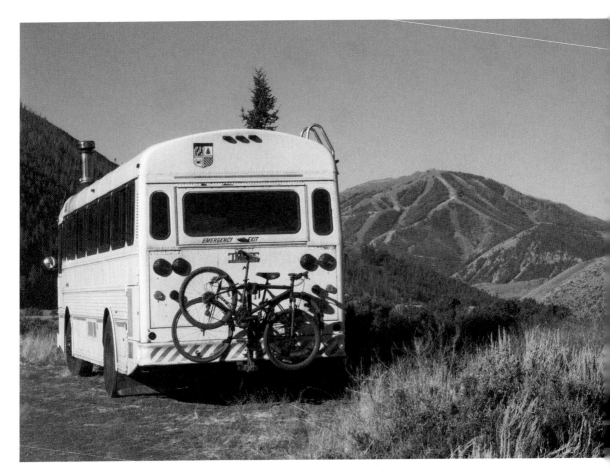

1999 Thomas Transit Bus (Towanda)
Sawtooth National Forest, Idaho
Contributed by Austin LeMoine

1999 Thomas Transit Bus (Towanda)
Sawtooth National Forest, Idaho
Contributed by Austin LeMoine

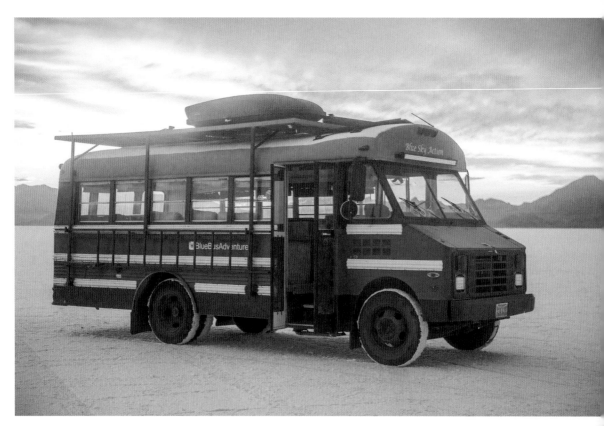
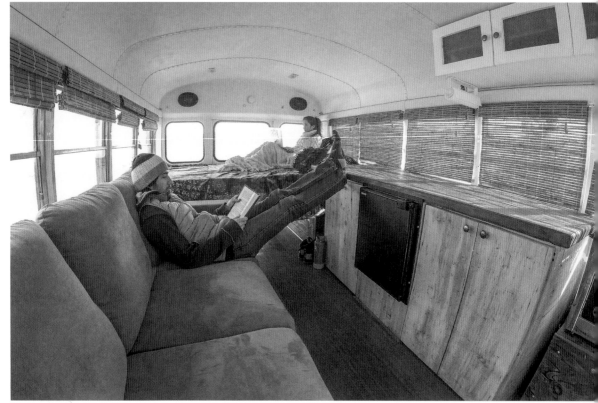

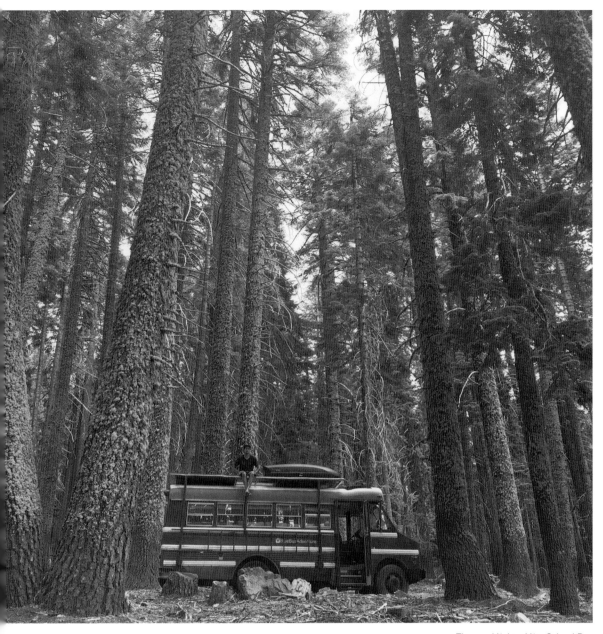

Thomas Mighty Mite School Bus
Above: Sierra City, California
Opposite top: Bonneville Salt Flats, Utah
Opposite bottom: Crystal Bay, Nevada
Contributed by Jessica Perez

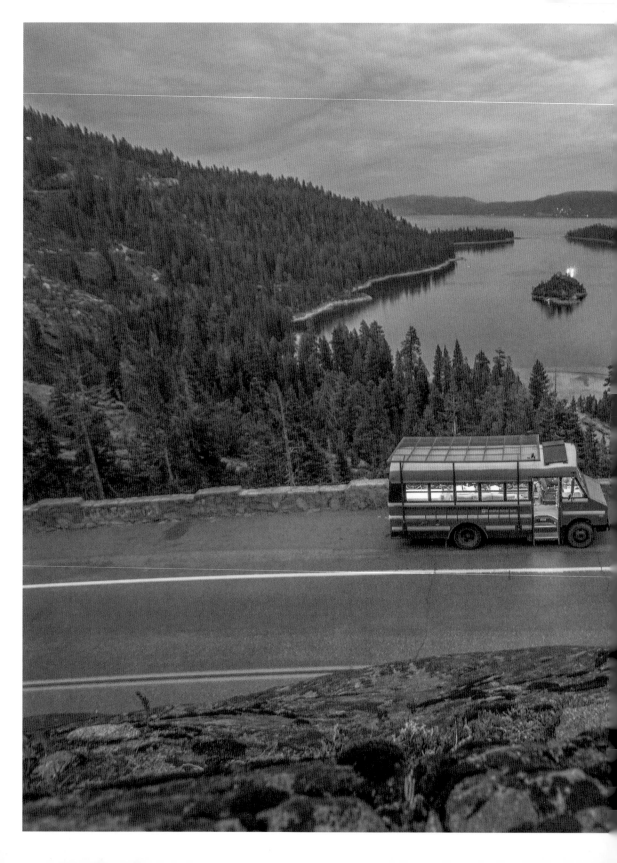

Thomas Mighty Mite School Bus
Boulder City, Nevada
Contributed by Jessica Perez

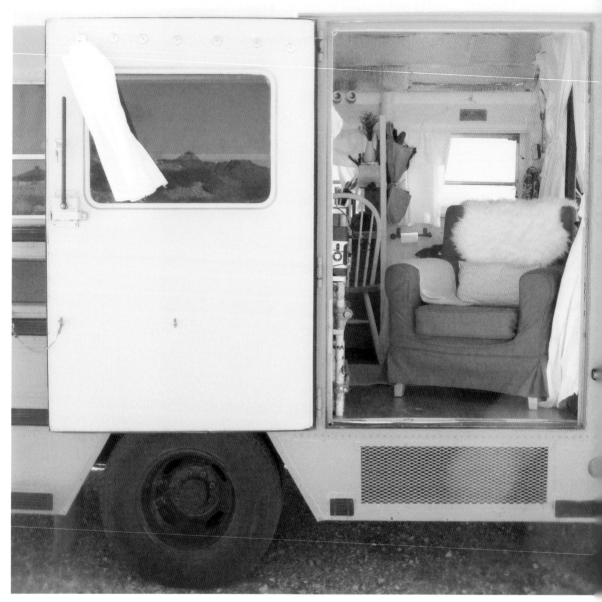

1992 GMC Vandura School Bus (Cozy)
Boulder City, Nevada
Contributed by Jennifer Lorton

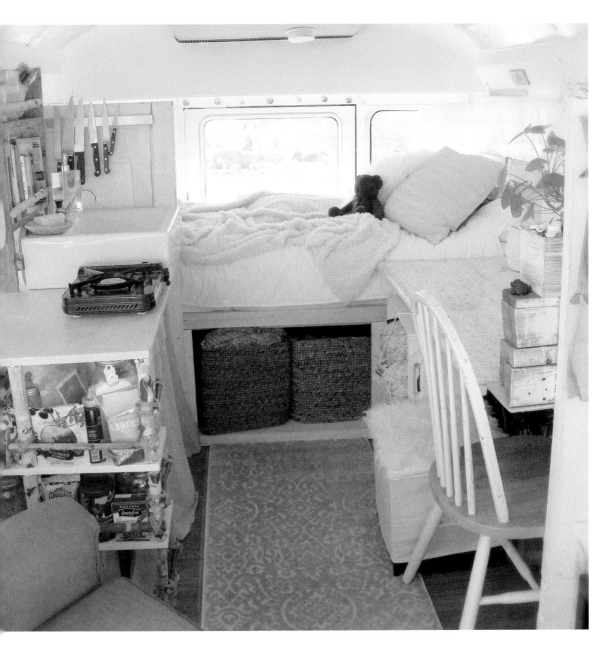

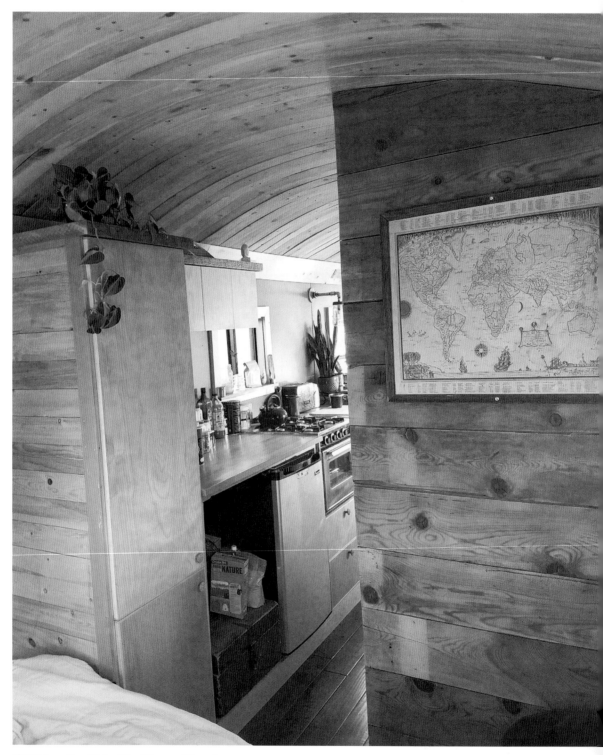

1982 International School Bus (Queen of Peace)
Above: San Luis Valley, Colorado
Opposite (top and bottom): Boulder, Colorado
Contributed by Charles M. Kern

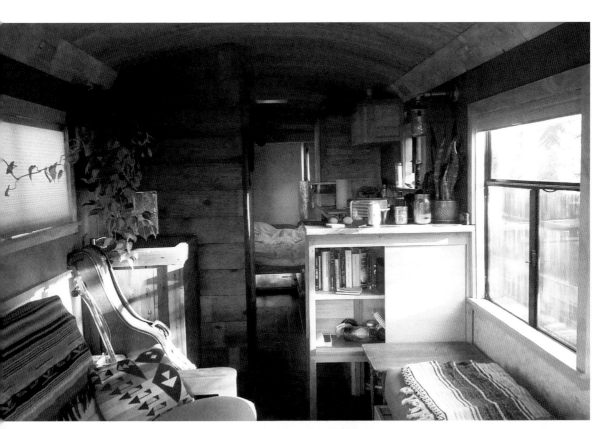

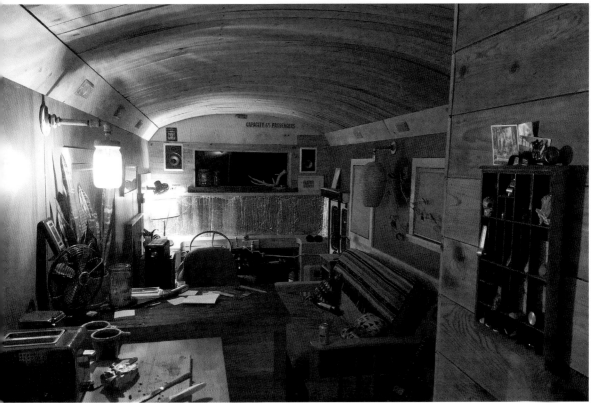

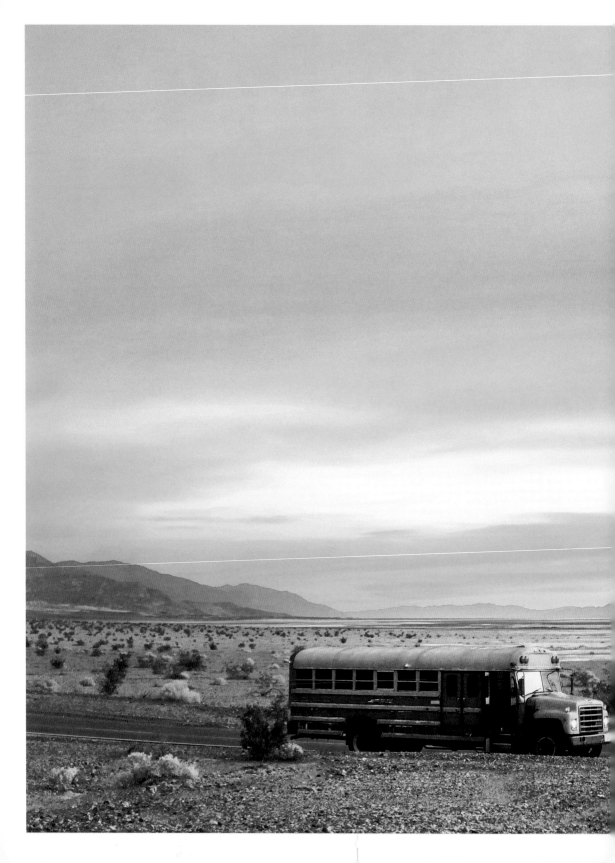

1989 International School Bus
(Gramps)
Death Valley National Park,
California
Contributed by Randy P. Martin

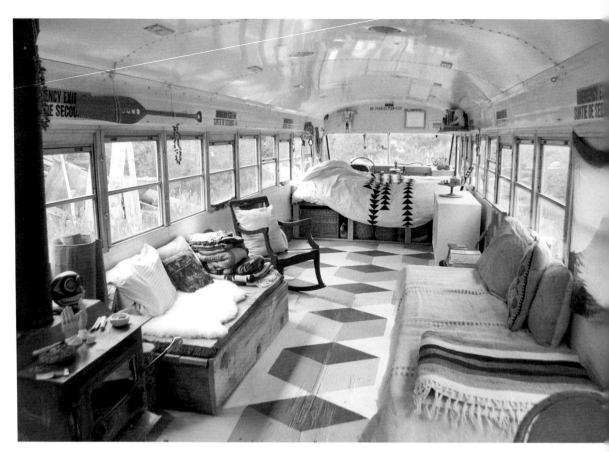

1986 Blue Bird School Bus (Tusk)
Lillooet, British Columbia, Canada
Contributed by Stephanie Jewel Artuso

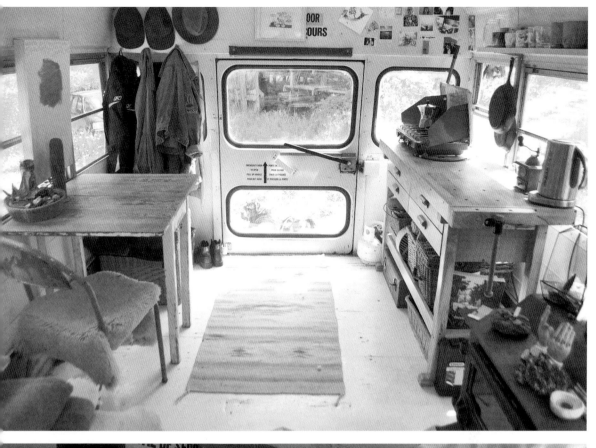
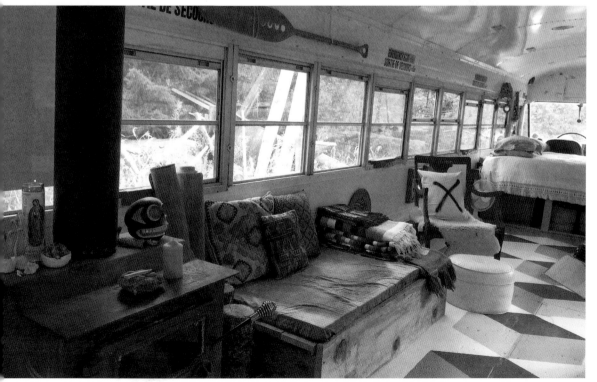

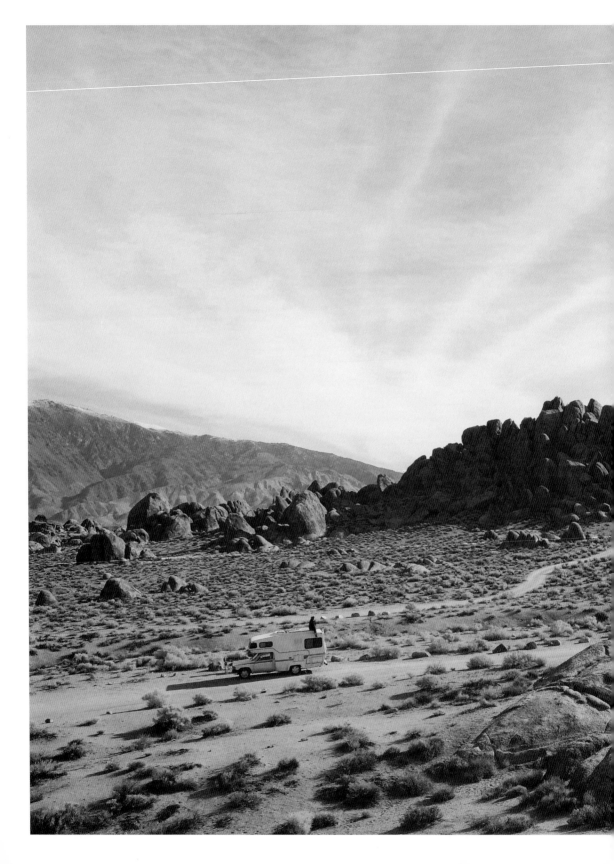

SMALL RVS AND CUSTOM CAMPERS

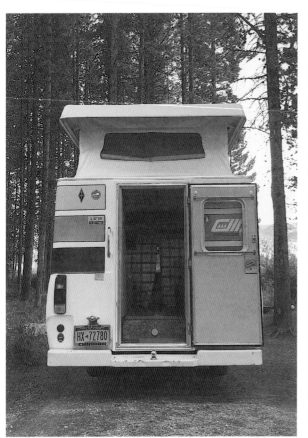

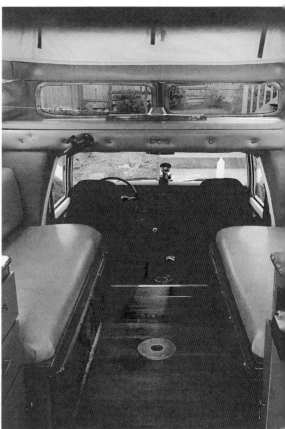

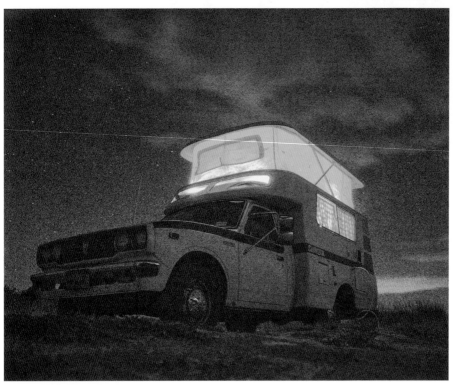

Previous page:
1985 Toyota Sunrader (Roam
Rader)
Lone Pine, California
Contributed by Stijn Jensen

Clockwise from the left: Custe
Gallatin National Forest,
Montana; Beaverton, Oregor
Warden, Washington

Mobile moto mechanic: David Browning pursues his love of vintage motorcycles and cross-country travel in his '77 Toyota Chinook camper.

People often ask me what kind of camper I'd recommend on a tight budget. I usually encourage them to start with a broad search, just to see what's out there. Think about the realities of how you'll be using it and what your travel priorities are. There are many lesser-known (and often more reliable) campers that are available at a fraction of the cost of the more popular vans and campers. David Browning has embarked on a North American excursion in one of these diamond-in-the-rough campers, a 1977 Toyota Chinook that provides more than enough space with its smart layout and still gets 22 miles per gallon—not bad for a forty-year-old camper powered by a four-cylinder engine.

FOSTER: Tell me about your Chinook. What year and model is it?

DAVID: It's a 1977 Toyota Chinook with the "dinette" layout. It has two bench seats, a center table, and appliances on opposing sides.

FOSTER: What made you decide to get a Chinook?

DAVID: New York City is an incredible place but can also be overwhelming. I started kicking around ideas for an escape pod and mobile workshop, so I could spend a few months each year in the city for motorcycle projects and the rest of the time on the road exploring and working.

I spent the mid-nineties touring the US with my old band in a Ford Econoline, and really dug that experience and mode of travel. I started looking for a similar van I could retrofit and stumbled across a photo of a Chinook Newport, which started my obsession.

I started kicking around ideas for an escape pod and mobile workshop.

FOSTER: How did you find it?

DAVID: There are not a ton of these guys out there in solid shape. A handful come up for sale each year nationwide. I was about travel to Tennessee to purchase a different Chinook sight unseen and did one more scan of the Northeast, where someone had just listed one in Long Island. At five the next morning, I hopped a train to buy it.

FOSTER: What modifications have you made?

DAVID: I decided to stay as close to stock as possible. It's brilliantly designed as is, and a neat little time capsule from that era.

As far as modern conveniences go, I installed a Bluetooth stereo for music and navigation, LED lighting to reduce power consumption, a propane/CO_2 sensor for safety, window tinting, and an outdoor shower and portable toilet. I also have some power banks and a portable solar panel to increase my power reserve.

Olympic National Forest, Washington

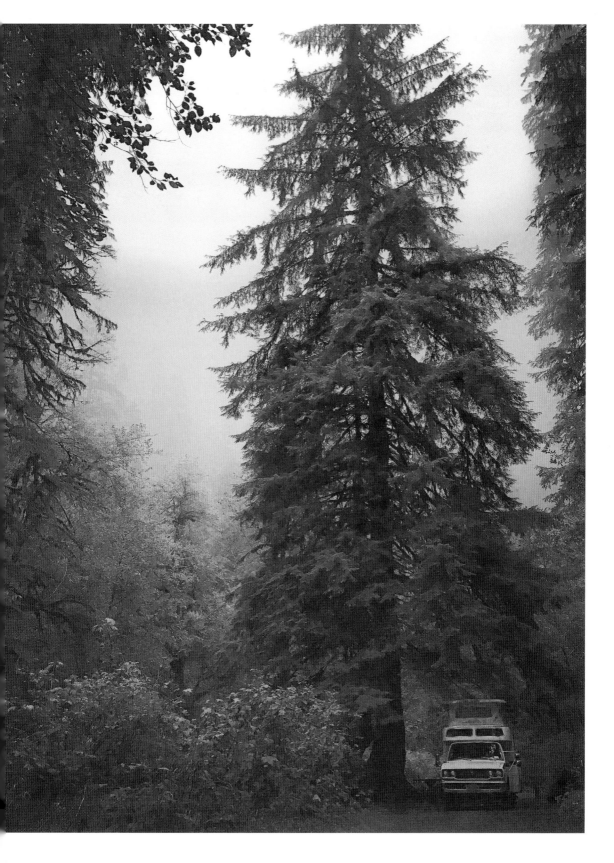

FOSTER: How do you use the interior space?

DAVID: I added closet shelving for my photography equipment and leatherwork tools. My five-foot-three Mini Simmons surfboard fits perfectly in the overhead area. I also stow a tent, sleeping mats and bags, awning, hammock, fishing gear, inflatable kayak, and a small guitar.

It works out awesome solo and is still comfortable traveling with a friend (but I'm used to living in a three-hundred-square-foot apartment).

FOSTER: Do you ever stealth camp in it?

DAVID: I spent around three hundred days in 2016 living out of the Chinook, mainly in national forests or on Bureau of Land Management property. I'm more a fan of getting off the grid versus city dwelling, so stealth isn't as much of a factor. That said, I spent a month stealth camping around Los Angeles without issue.

FOSTER: What was your first trip that you took it on?

DAVID: I drove to Bear Mountain, New York, for an initial test run and to determine what work was needed prior to any extended travels. The next day I sourced all the needed parts and got to work on the engine and some restoration efforts. About two weeks later, I made a huge, long loop from Florida to California to Colorado to the Pacific Northwest before heading home.

FOSTER: What would you change about the Chinook?

DAVID: Of all the vehicles I've owned and restored, the Chinook is one of the best-designed platforms I've come across. However, the fiberglass roof and wood flooring could use

Central Oregon

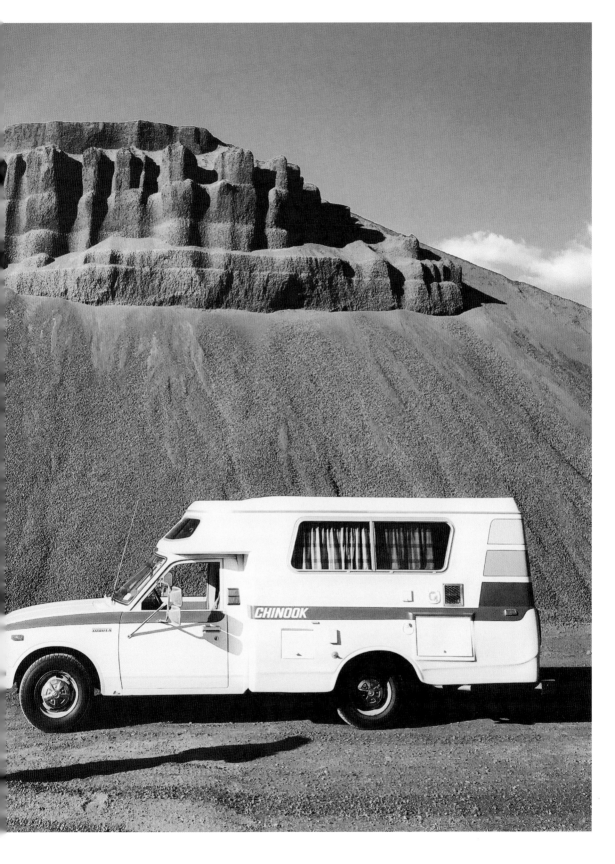

reinforcement to prevent sagging over the years. The insulation could also be improved. I've been out on nights as low as nineteen degrees, but that's with the furnace blasting, top down, and multiple layers of clothing and blankets.

The fuel pumps are located inside the gas tank, which is difficult to access should it ever need replacement, but that's more a Toyota thing than Chinook's fault. I also wish it had the weight capacity to add a motorcycle carrier for a compact ride while out traveling.

FOSTER: Have you had any mechanical troubles with it?

DAVID: As with all vehicles that are approaching forty years old, it requires a fair amount of upkeep. I did some top-end work and general maintenance and rebuilt the brakes, suspension, and most of the drivetrain. I try to do as much preventive maintenance as possible but also carry a toolkit and commonly needed parts.

I had a water pump fail in the desert in Arizona. Lost a clutch slave cylinder in Malibu a few weeks later. The clutch master cylinder went out in Oregon after that. Then the distributor got all weird. That was a tough one to troubleshoot and took until Kentucky to fully understand and sort out, but most of the issues were relatively easy to address. I'd recommend having some basic mechanical knowledge and the factory service manuals if

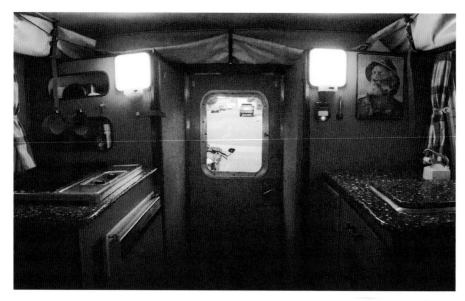

Beavertown, Oregon

Opposite: Bridger-Teton National Forest, Wyoming

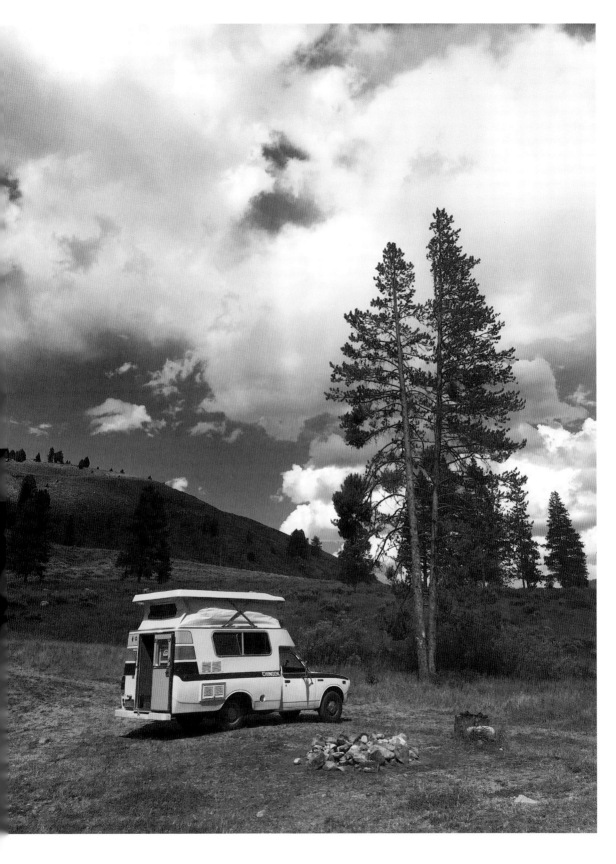

you're planning to travel in a Chinook, but overall it's a great, dependable platform.

FOSTER: How do you like the walk-through?

DAVID: The Chinook is a bit vertically challenging for me at six foot two. There's just enough roof clearance with the top up to stand, and I've got to sleep on an angle as the bed is a few inches too short for a tall guy. The pass-through from cab to camper requires some contortionist twisting for me, but it is nice to get back there without having to exit the vehicle.

FOSTER: Has it been reliable? How do you like the 20R motor?

DAVID: I traveled around twenty thousand miles in 2016 and only broke down a handful of times. The 20R engine has proven to be super dependable and rock solid. It's up there with the Honda CB550 SOHC4 as my favorite engine designs of all time.

FOSTER: What kind of gas mileage do you get?

DAVID: I was getting 16 to 18 miles per gallon to start. After adjusting the valves to spec, tuning the carb, and conducting general maintenance work, it went up to 20 to 21 miles per gallon. I'm currently getting 20 to 23 miles per gallon post–Weber 32/36 carb conversion.

FOSTER: What's one piece of advice for someone considering taking an extended twenty-thousand-plus-mile trip?

DAVID: The one piece of advice I could offer is to learn as much as possible about your vehicle prior to departing for your trip. Become familiar with your rig and brush up on basic mechanical and electrical troubleshooting. Something is bound to break at some point, and having the parts with you can be the difference between a quick roadside repair or an expensive tow bill and unplanned downtime in the desert. Time invested in learning some basic repair skills and sourcing parts will pay off tenfold once out on the road. Carry a service manual and full toolkit, and plan to keep a stash of commonly needed parts and maintenance items on hand.

1967 Avion Cabover Camper (The Buggy)
Bozeman, Montana
Contributed by Blakeney Sanford

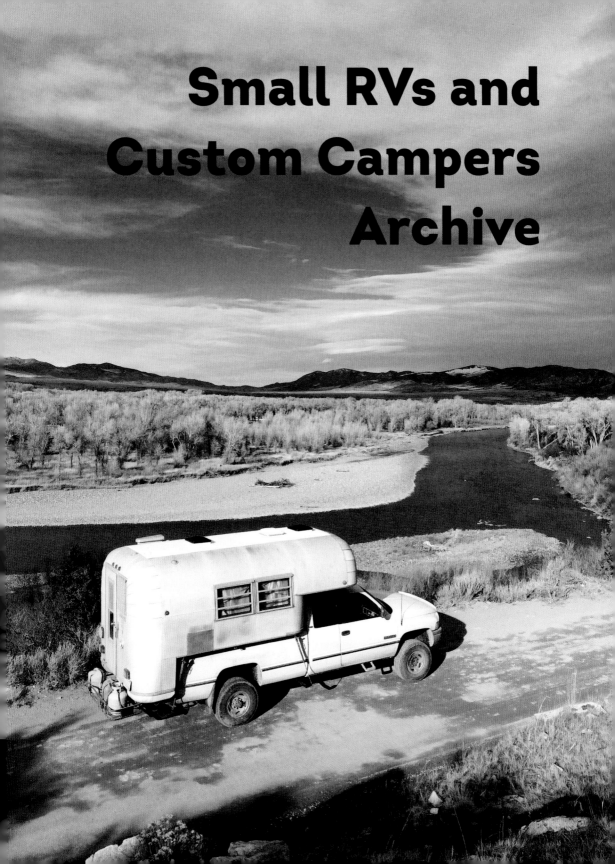

Small RVs and Custom Campers Archive

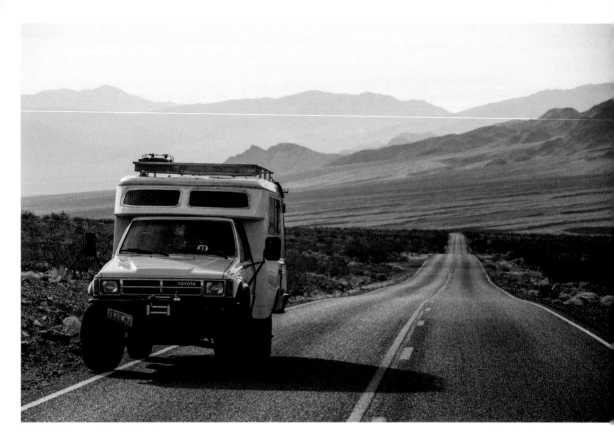

1988 4x4 Toyota Hilux Chinook

Above: Death Valley National Park, California

Opposite top: Juan de Fuca Provicial Park, British Columbia, Canada

Opposite bottom: Lake Minnewanka, Banff, Alberta, Canada

Contributed by Adam Smith

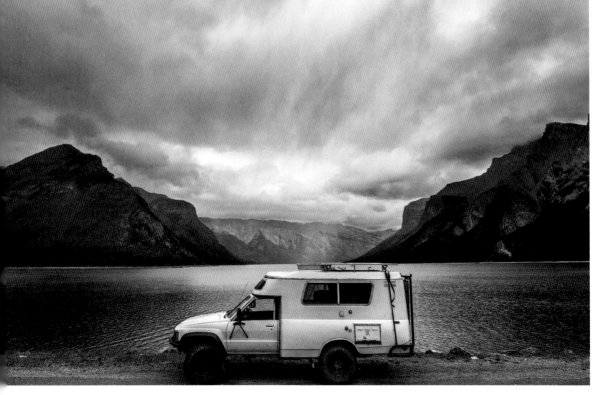

1984 Nissan Odyssey RV (Justo)
Castle Valley, Utah
Contributed by Isaac Johnston

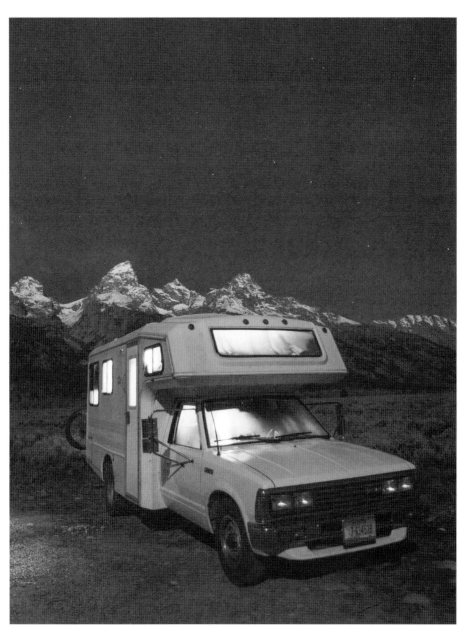

1984 Nissan Odyssey RV (Justo)
Grand Teton National Park, Wyoming
Contributed by Isaac Johnston

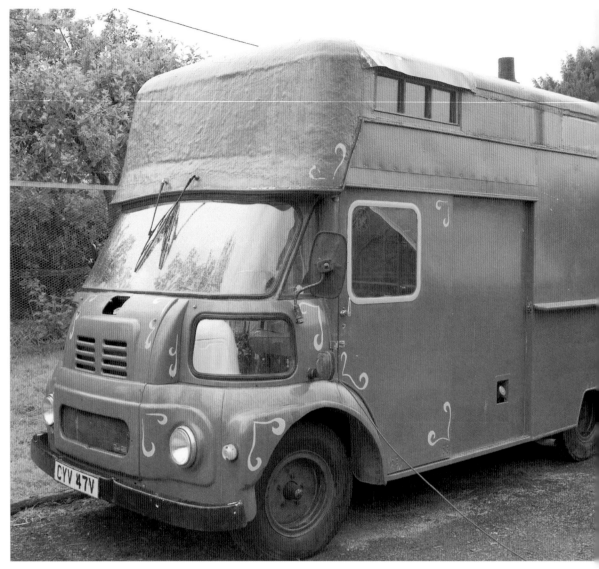

1979 Leyland FG (Molly)
Above and opposite: Herefordshire, England
Contributed by Bill Goddard

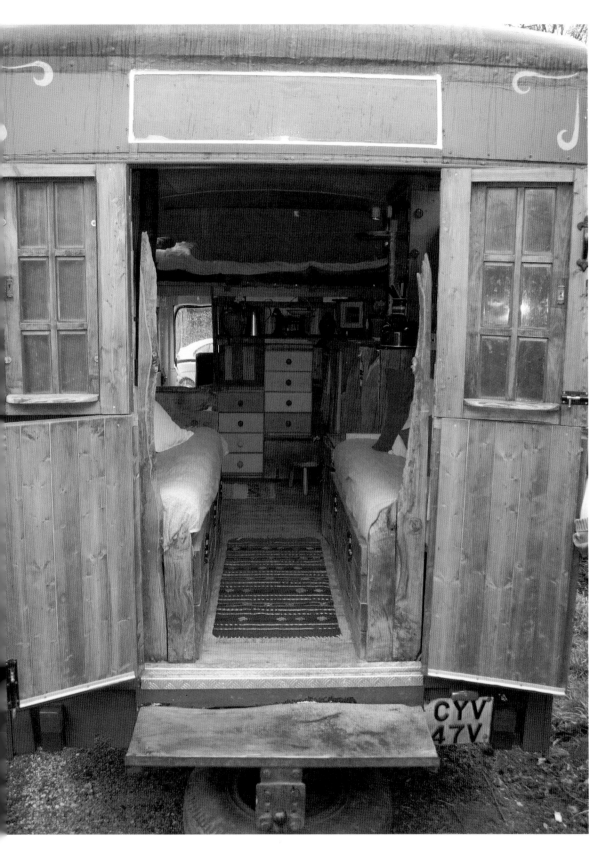

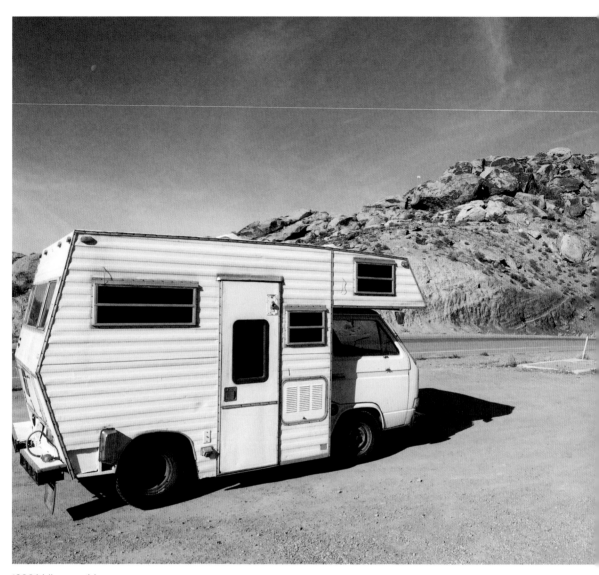

1980 Volkswagen Vanagon
Utah
Contributed by Sarah Bergland

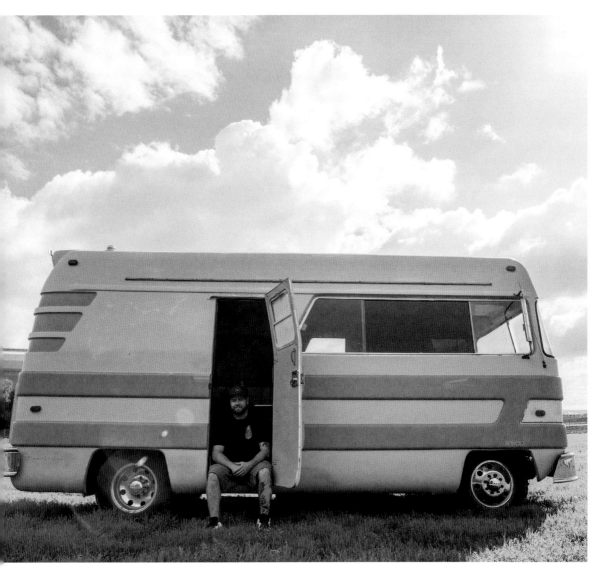

1970 Starcraft Starliner
Irvine, California
Contributed by John Power

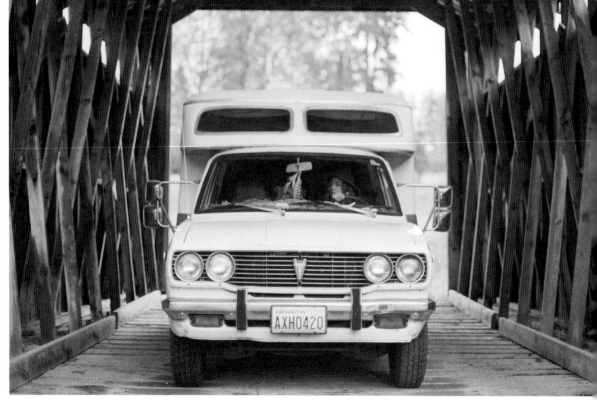

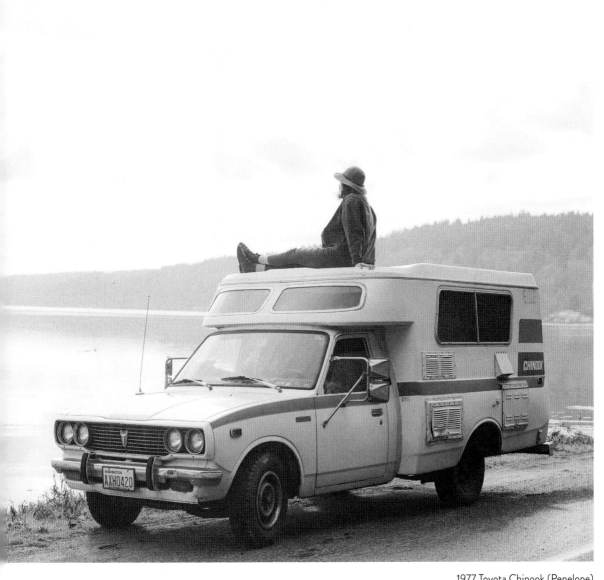

1977 Toyota Chinook (Penelope)
Above and opposite: Vashon Island, Washington
Contributed by Camille Casado and Garrett Hystek

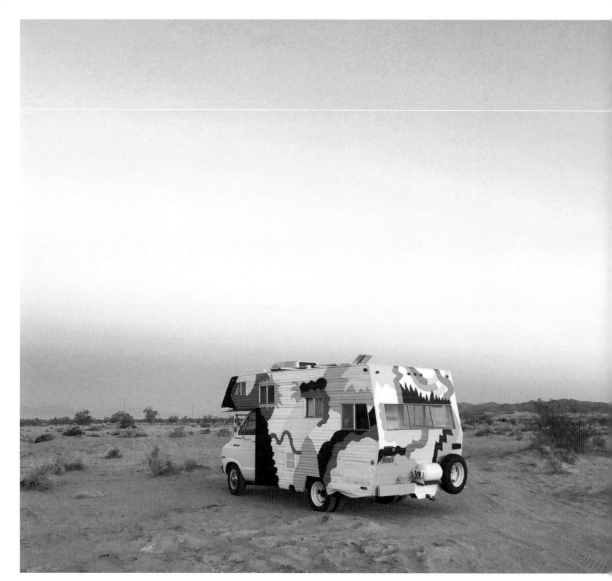

1974 Dodge Sportsman (Sunny)
Slab City, California
Opposite: Big Sur, California
Next page: Mount Tamalpais, California
Contributed by Frankie Ratford

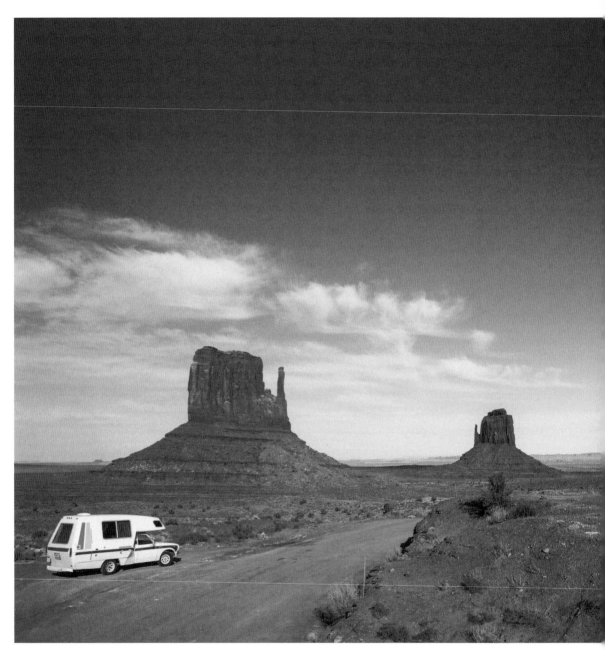

1978 Toyota Chinook Newport
Monument Valley, Utah
Contributed by Peter Kappen

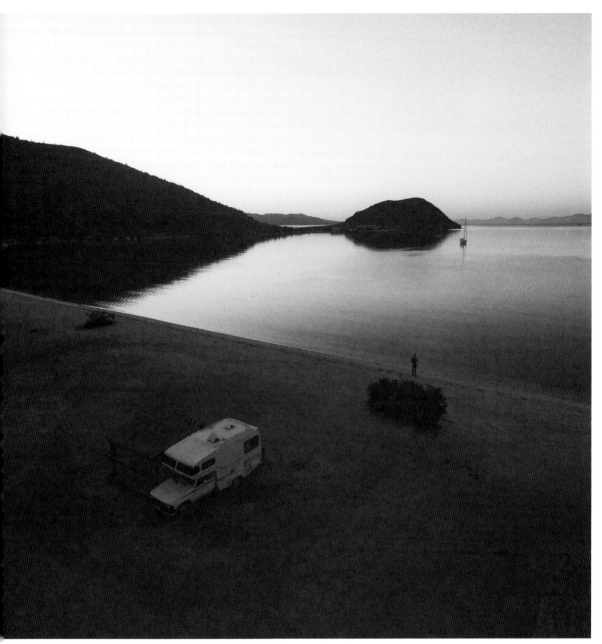

1985 Toyota Sunrader (Roam Rader)
Bahia Concepcion, Mexico
Contributed by Stijn Jensen

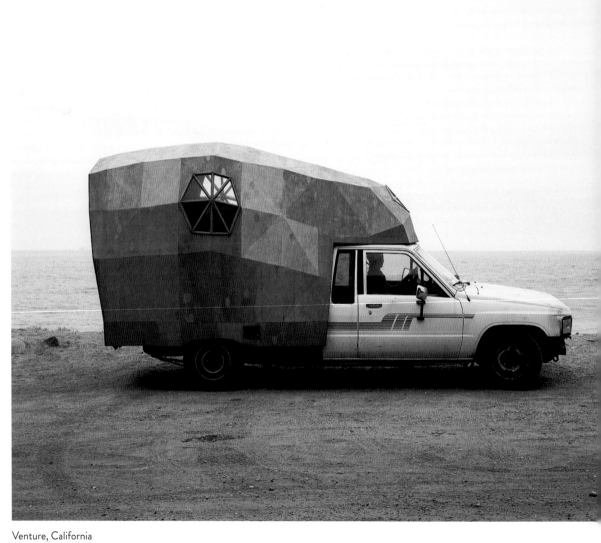

Venture, California

The art of movement: Jay Nelson's vehicle conversions keep blurring the lines between fine art, home, and transportation.

Seeing one of Jay's camper builds always puts a huge smile on my face. They're so weird, unconventional, and utterly original. When I take in his entire body of work over the years—all the cars and boats, the jeeps and trucks, the pods, forts, and installations—that's when I realize how much I admire Jay's output. Hands down, he's one of the most talented artists, painters, sculptors, and builders creating today. The way he customizes, repurposes, and rethinks vehicles and living spaces is a revelation. I like his work so much that I commissioned him to adapt my tiny Suzuki SJ410 a couple years ago, and the final result was incredible—a boxy little four-cylinder truck with a round six-foot over-the-cab camper made of marine plywood and finished

with a wrap of copper sheeting. I try to stay in touch with Jay regularly because whether we're talking surfing or his next project, he forces me to consider my own work from a fresh angle.

FOSTER: So how did the original Civic camper come to be? Were you living in New York?

JAY: No, it was right after college. I was like twenty-two and I lived in the back yard of these Hare Krishnas' house in this little shack for really cheap rent. A friend of mine's mom got in a car accident in a '92 Honda CRX and sold it to me for like two hundred bucks because it was all smashed. I had no car at the time, so I just bought it. But it had a big hole and rain was coming in. First I tried Plexiglas, but that didn't really work. So then I started thinking about putting a box on top of it—not like a hatchback, but a square—and then thought about a bed on top of the box. I just built it out in front of Mollusk [surf shop in San Francisco, California] and finished it in Luke Bartels's wood shop in San Bruno.

Then I moved to New York and drove it out there in the winter when I was twenty-four. When I first built it, I wasn't living in it permanently. In general, I'm not one to live in campers full time, but I really love the idea of being able to leave for like a week or two. I had the CRX camper out in New York, and one summer we just drove to Nova Scotia, across Canada, and then down to Montana.

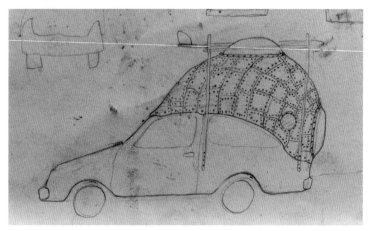

Bar Harbor, Maine

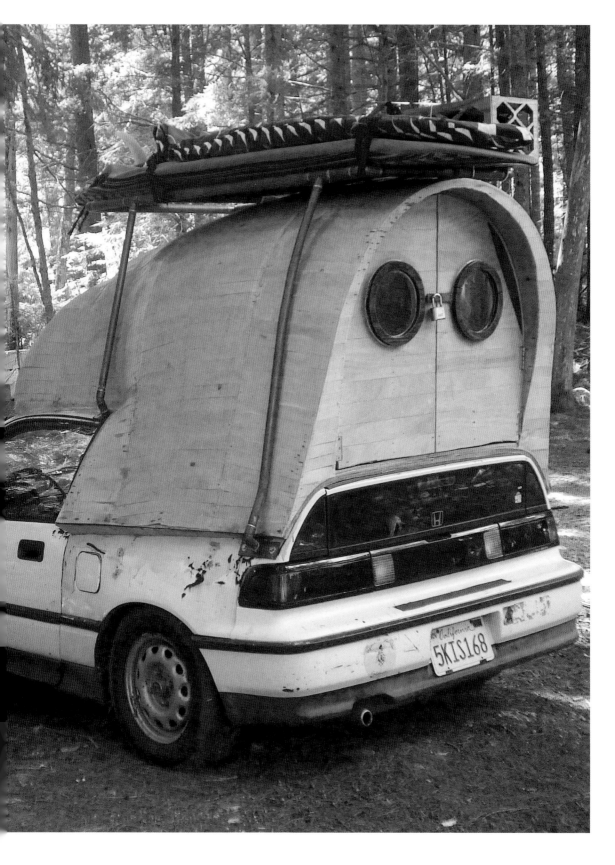

FOSTER: So did you build that out of fiberglass? Marine ply and fiberglass? How did you make it?

JAY: No, it was wood. It's pretty funny, actually—I was so poor at that time that I got all these scraps from this surfboard builder. He had all these leftover long, narrow strips that were like two inches wide but eight feet long. I used those long strips to bend around the frame and then I fiberglassed it, which was a total mess. I didn't make much of a smooth surface for the glass to go on, and that's ultimately what led to its downfall. What I've learned is that if you're building a camper shell you want to make a smooth surface with plywood. Then you want to Bondo the whole thing so you fill in all the cracks and holes, then sand it, then put the fiberglass on. Sometimes fiberglass has these little pinholes, and rainwater can get inside those holes and mold the wood. That's what eventually happened with the CRX camper, but it took a long time. I had it for eight years before I finally dismantled it.

FOSTER: So what came after that? What have you been working on more recently?

JAY: Lately I've been getting back into projects like the CRX. I feel like I kind of peaked with the Patagonia Worn Wear truck as far as really being focused and spending a lot of time on something. And then also with, like, your camper [Suzuki SJ410] and the Visla van. Both of those I made in like two weeks. I've been more interested in more limited budgets and working faster. With the Patagonia truck it was a challenge, because the budget was so big I could almost do anything and I could spend as much time on it as I wanted. I think it came out rad and is good for what it was, but I think for my own personal campers I wouldn't want to do that. I want to build something that would be more immediate.

FOSTER: I've always admired your ability to crank stuff out quickly. You're very prolific in terms of being able to make stuff fast that's really good. I guess at some point, there's diminishing returns.

JAY: I don't really like building for other people in that way anymore because it feels like you have to make them perfect for other people. At this point now it's like every week I'm getting emails from people or companies to build them something. And with Patagonia there was a lot of pressure, and I wanted to make something really epic for them and that's the challenge. If I'd been making it for myself I wouldn't have done all that. Even with a

good budget, I wouldn't have spent that much time on it.

FOSTER: Yeah, I know. We've talked about this before—when I was building out my Toyota truck camper, I experienced something strange. I got super focused on making it really nice and fancy, and in its perfection it completely lost its charm, at least for me.

JAY: Yeah, that's always the challenge. How do you move forward and get better without perfecting anything? You want to keep it wild and loose. That's a big theme in art. Like with painting. Little kids make the best paintings, bottom line. You'll never make anything better than a kid. So how do you move forward with all your life experiences and all these ideas you have, but also kind of go backwards at the same time?

FOSTER: What advice would you give to someone who is inspired by the campers you make and wants to take a stab at building their own vehicle?

JAY: My advice is that you just have to start. Every project feels intimidating, but there's not going to be any step that's ever harder than starting.

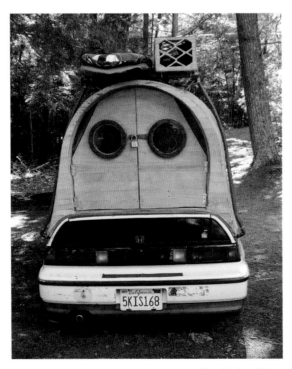

Bar Harbor, Maine

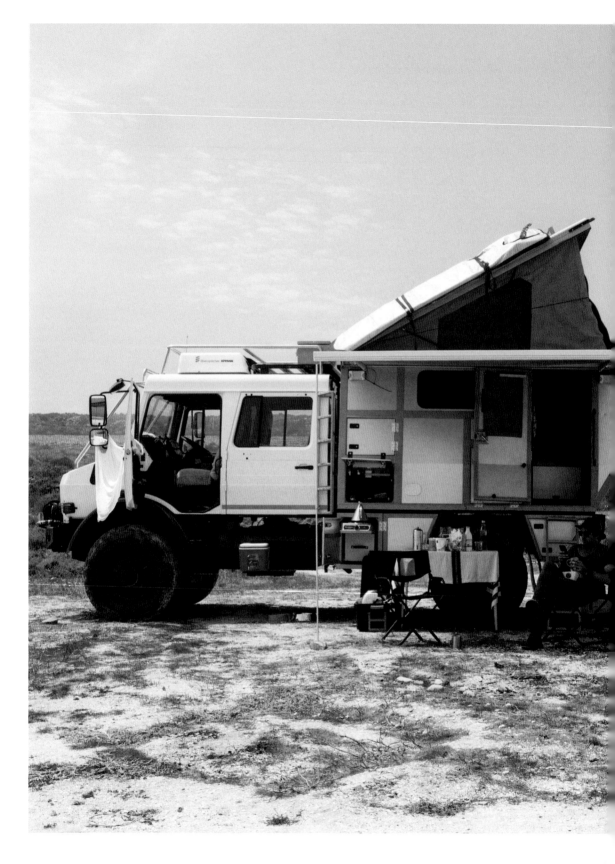

CHAPTER 8

TRUCK CAMPERS AND 4X4S

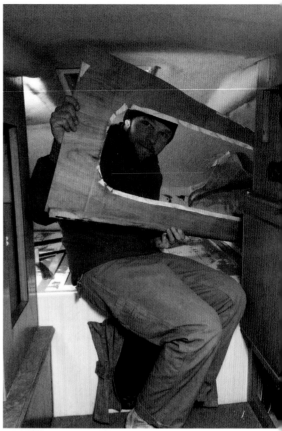

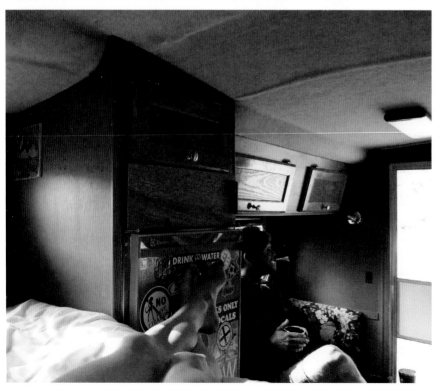

Previous page:
2012 Mercedes-Benz Unimog U 4000
West Coast, South Africa
Contributed by Svend Rands

Clockwise from the left: Truckee, California; Portland, Oregon; Truckee, California

Evolution of a snow chaser: Tim and Hannah's Ford F-250 custom camper build is purpose-made for finding the fresh stuff.

These two are the dream team. Tim has been a snowboard pro for over a decade, and Hannah is an amazing skater and surfer in her own right, as well as a trained pastry chef. They make their home up and down the West Coast in their Ford F-250 Radical Roamer, surfing, boarding, biking, and raising awareness around environmental issues. When they're not roaming, their home base is an incredible tiny cabin they built in the mountains in Truckee, California. I love the positive energy they bring to everything they do, and I admire their constant desire to test themselves out in the elements.

FOSTER: So, did you guys ever come up with a name for the camper?

TIM: Oh, yeah. The Radical Roamer.

FOSTER: I want to talk about the evolution. You had the Ranger with the four-wheel when we first met, right?

TIM: The evolution has been sleeping in the back of our Subaru, to getting the Ranger with the camper shell and classic plywood-level bed frame in there. And that wasn't very sustainable long term. It was sweet for like a week, and then we realized it wasn't working and winter was pretty brutal. So we thought a pop-up was the answer. We had the Ranger and needed a small camper to fit on it, so we got that. It kicked ass, but we were looking for a camper we could spend months and months in, specifically in the winter. We wanted to embrace the cold weather instead of trying to avoid it. And the pop-up was kind of hectic on a stormy night up on a mountain pass. It was never that conducive to pursuing snow. And then that's where we've come to now—the all-encompassing camper. We've put everything we've learned and everything we wanted into this rig that we've got now.

FOSTER: So what's the story on your truck?

TIM: The truck is a '94 and it's a turbo. It's the 7.3 turbo. It's pre-powerstroke, technically—more like 1994 and a half. In late '94, Ford released their first turbo diesel and it's apparently supposed to be one of the best because it's their introduction into the turbo diesel market, so they put everything they had into it. It was a rad find for sure.

FOSTER: Were you looking for the truck for a while? Where did you find it?

Baja, Mexico

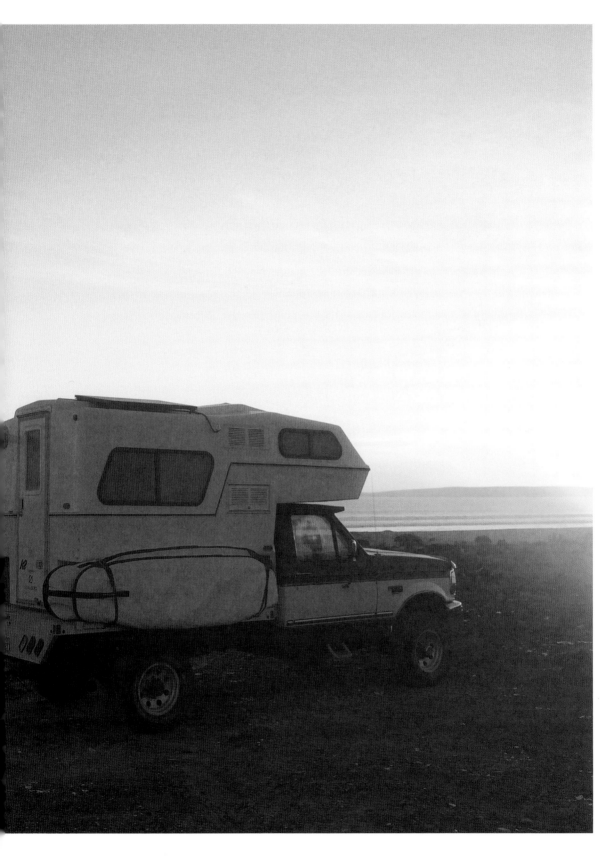

TIM: We were pretty specific. We wanted the two-door turbo diesel, so it took a while to find. We actually discovered it on craigslist in Sandy, Oregon. It only had 130,000 miles. We jumped right on it and hooked it up right away. We had already bought the camper before we got the truck. We were also looking for that specific camper for a long time.

FOSTER: So what's the camper?

TIM: It's a 1993 Northern Lite, the 610 model. It's made for tiny trucks. It's designed to fit a Ranger or an early Tacoma. They're small and super hard to find. We were in Tahoe and one popped up on craigslist and I arranged it, so we flew up to Portland and landed at 11 P.M. Hannah left for work at 4:30 A.M. and I drove all the way up to Squamish, near Whistler [British Columbia, Canada], threw it on the Ranger, and drove back to Portland that night. We put it in the garage and put the 4x4 Ranger up for sale the next day.

FOSTER: Was it a pain in the ass to get it back across the border with the camper? I've heard horror stories.

TIM: That's a hilarious story, because at the time I was thinking that it could get interesting with taxes and all that kind of stuff. I drove up, bought it, and right before I crossed the border I went to a Goodwill and donated everything in the back of the camper that

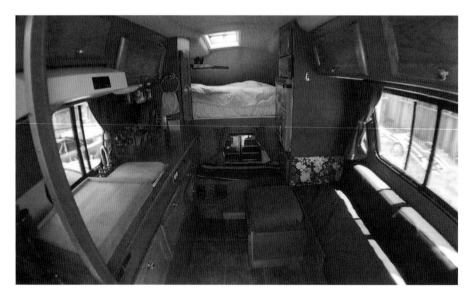

Santa Cruz, California

looked like it was Canadian—a bottle opener that had a Canadian flag on it, paper plates that were obviously bought in Canada. I got rid of anything that was going to give any hint of a previous Canadian owner. I drove through the border all nervous, thinking I was going to have to figure out all these taxes and paperwork, and the dude at the border said like three words to me. So classic. Luckily, in the end it was pretty damn easy.

FOSTER: So then you guys bought the truck, took it to Reno, took off the bed, and went berserk with the flatbed, am I right?

TIM: We took it down to Mammoth, California, before we flat-bedded it because our buddy Scotty helped weld a platform for the camper to go on the back of our regular bed. It was too small to fit into the regular bed; we had to raise it up. We basically finished it the day before we left for Mammoth for a snowboarding thing. But we nearly tipped it over in Mammoth. It was completely out of balance. After that whole incident, we were like, we've got the truck. We have the camper, but we don't have the solution to making them one whole cohesive unit. They're fighting each other. It's not working. So then we hit up our buddies in Reno who own a metal fabricating shop, and they gave us space and were stoked to work on it with us. So we looked on craigslist and found an aluminum flatbed that this guy bought and brought home only to realize it didn't fit his truck and he couldn't return it. It was perfect for our truck. At the shop we did all the hardware and bracket fabricating and wiring, and we pieced it all together in Reno.

FOSTER: From there, what did you do to the inside?

TIM: The inside was sweet—we did all that in Portland last winter. We had it parked in the garage at the house we were renting and it was raining all winter, so we just worked on it every day. The whole front end with the cab-over where the bed was had a leak and was all water-damaged. So we ripped out the wood paneling and the insulation, pulled the windows out, re-caulked, and installed new brackets for the windows and got new insulation and new panels. We repainted the whole thing. We retrofitted a table for the interior and pulled all the electronics out and switched it to solar. We ripped the furnace out, replaced it with a woodstove. The seat cushions were super gross, so we had those reupholstered with extra Airblaster outerwear scrap material so they're super waterproof and rugged. We had to re-caulk the entire exterior and fix the hole we put into it. When we moved it

into the garage we hit the garage door and popped a hole in the roof, so we had to fix that. That was cool.

FOSTER: So you pretty much built a camper from scratch.

TIM: Basically we bought it for the fiberglass shell. It's so bomber and all insulated and super lightweight, only like 830 pounds. It was the one we wanted; we just needed to do a lot of work to it. And it all paid off. Now it's so sick in there.

FOSTER: Yeah, and I'm not that big of a fan of pop-tops.

TIM: Dude, same. Ever since we've been in our hard-shell cab-over, we can never have a pop-top again. Having the ability to pull up and just sleep somewhere real quick with tons of storage is incredible. You don't feel like you're in a tent, you feel like you're in a little home. So much warmer and way less condensation. It's definitely the best version that we've found.

FOSTER: Another mistake people make is that they think, "my camper only weighs six hundred pounds, it's going to be fine on my half-ton pickup truck," and then as soon as you start adding weight the truck doesn't handle right and it's dangerous.

TIM: Totally, dude. That's what drove us to being so focused on that truck and this small camper. It's a one-ton suspension and the engine way overpowers the weight so it handles amazingly well and it's never sketchy; you can just charge in this thing. In the Ranger we always worried that we had a little too much water, or we couldn't take that snowboard also because it was going to weigh too much. It's not a good feeling. You want to be confident, not second-guessing everything.

FOSTER: Where is your next trip planned with the Radical Roamer?

TIM: Next trip starts Wednesday to the mountains surrounding Bend, Oregon. From there we go on a grand tour up through Washington, interior British Columbia, Montana, Utah, and back to the Sierras. What can I say, we're snow chasers.

2003 Chevy Suburban Pop-Top Custom (Mervin)
Big Sur, California
Contributed by Ian Boll

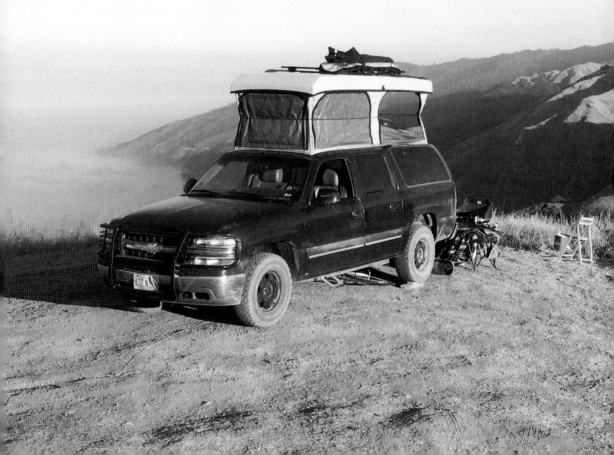

Truck Campers and 4x4s Archive

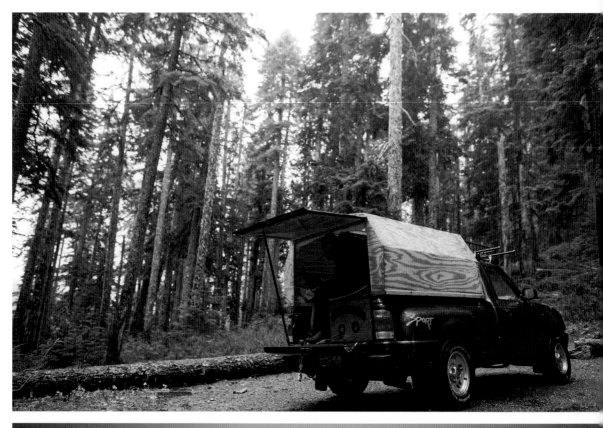

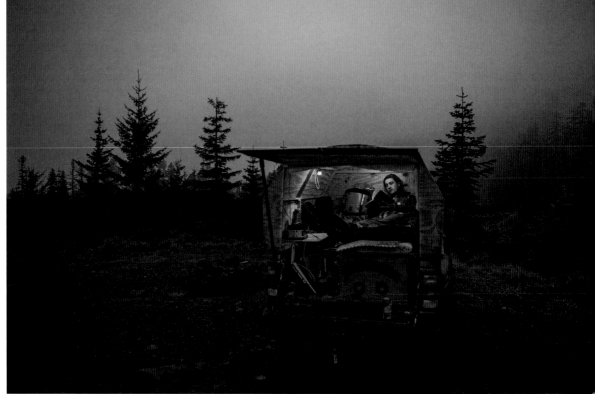

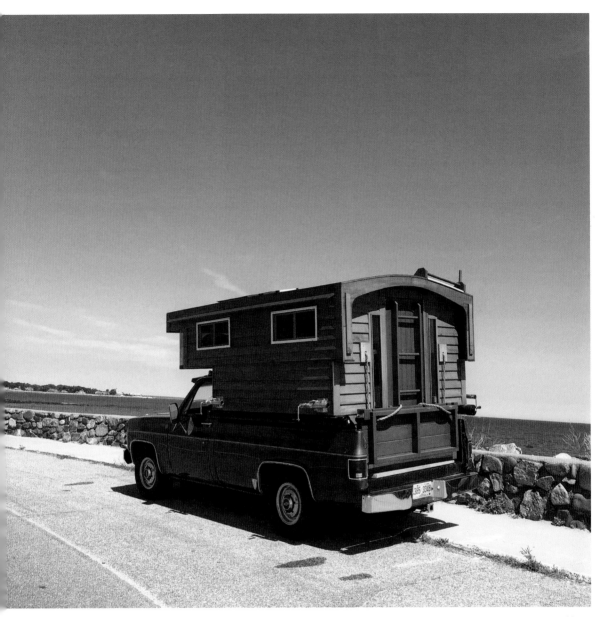

Above:
1977 Chevy Scottsdale Custom (The Cedar Escape)
Rye Beach, New Hampshire
Contributed by Sarissa Sevincgil

Opposite:
1999 Ford Ranger Custom
Hood River, Oregon
Contributed by Ben Matthews

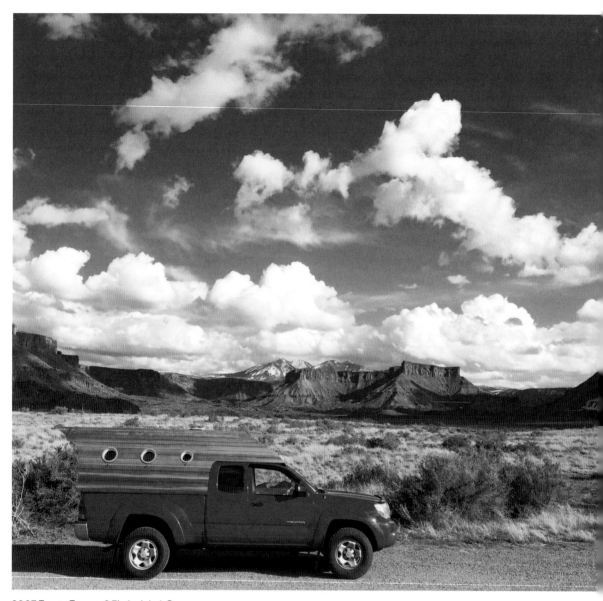

2007 Toyota Tacoma 2.7L 4cyl 4x4 Custom

Above and opposite top: Moab, Utah

Opposite bottom: Randle, Washington

Contributed by Clifton Hart

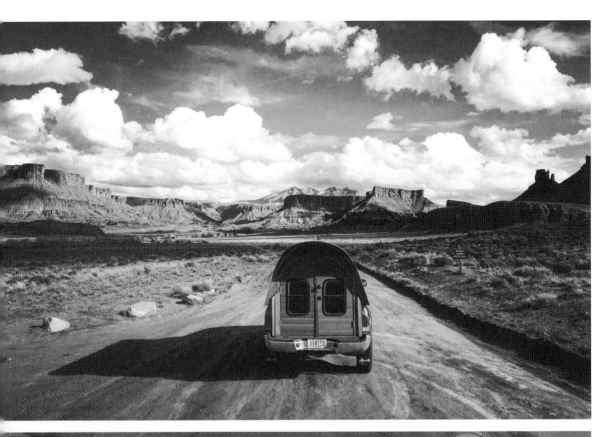

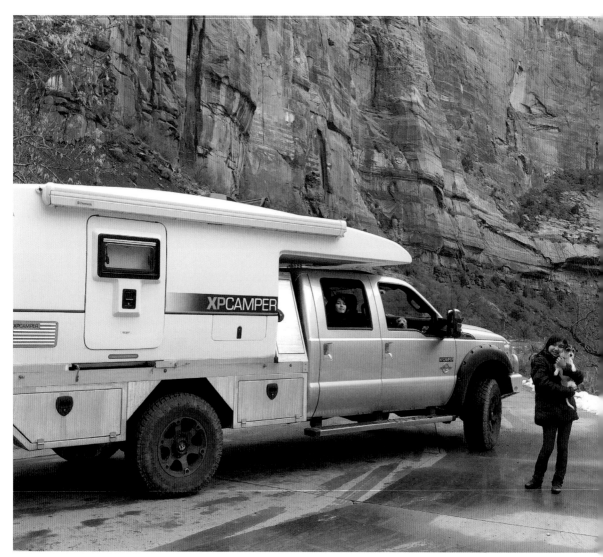

XP Camper V1 on 2016 Ford F350
Zion National Park, Utah
Contributed by Grace Wexler

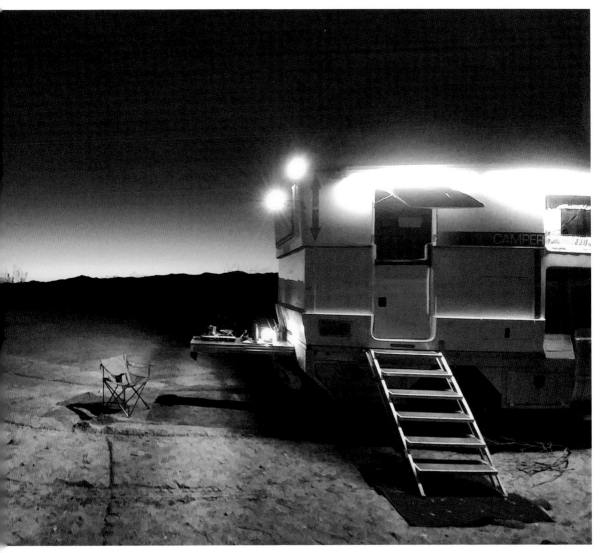

XP Camper V1 on 2016 Ford F350
Red Rock Canyon State Park, California
Contributed by Grace Wexler

1993 Toyota Hilux Custom (The Backwoods Bed)
Putney, Vermont
Contributed by Ben Shumlin

Next page:
2003 Chevy Suburban Pop-Top Custom (Mervin)
Canyonlands National Park, Utah
Contributed by Ian Boll

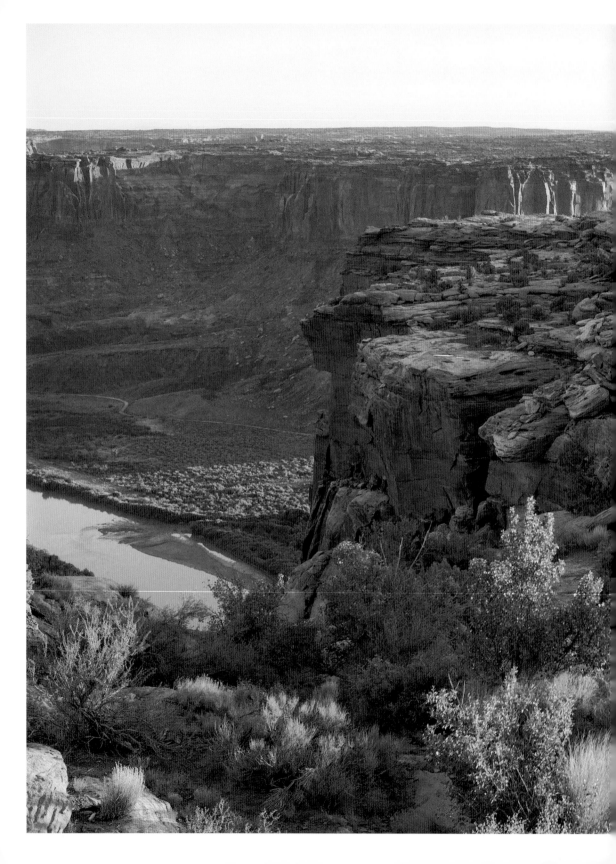

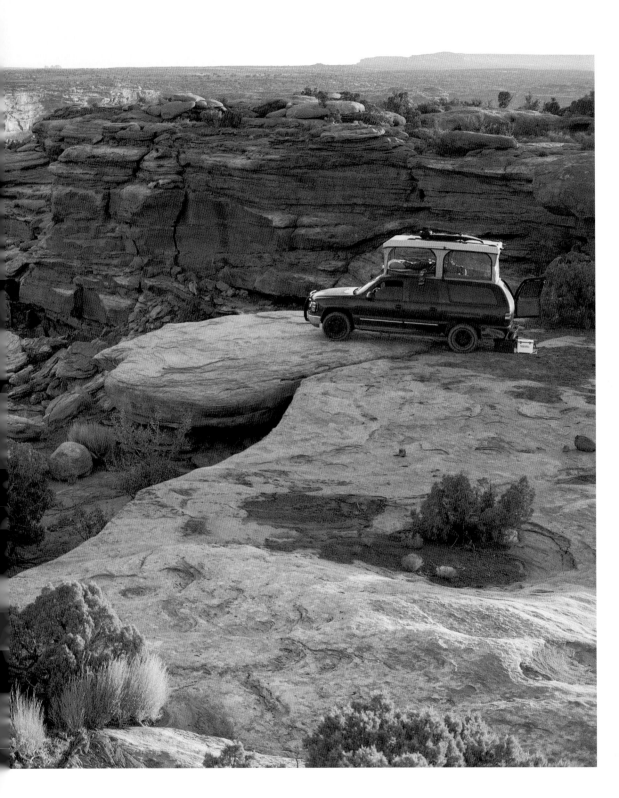

2003 Chevy Suburban Pop-Top Custom (Mervin)
Canyonlands National Park, Utah
Contributed by Ian Boll

2016 Ford F-250 Super Duty Crew Cab Long Bed 4x4 + 2016 Grandby Four Wheel Pop-Up Camper
Opposite top: Punta Camalú, Baja California, Mexico
Opposite bottom: Manitoba, Canada
Contributed by Mali Mish

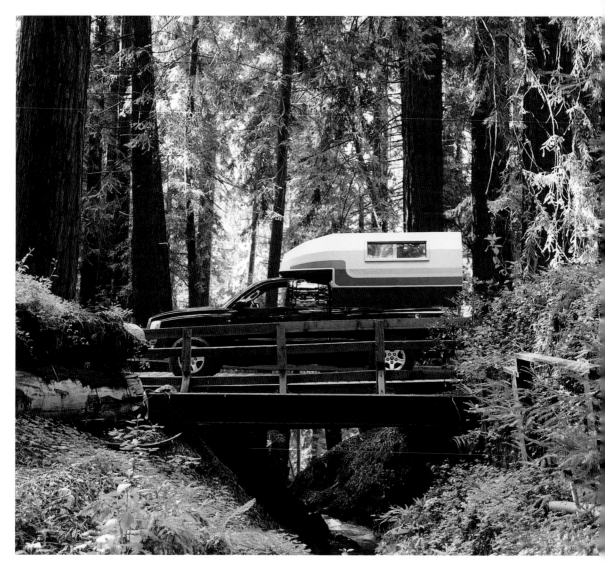

2005 Dodge Dakota
Big Sur, California
Contributed by Schuyler Robertson

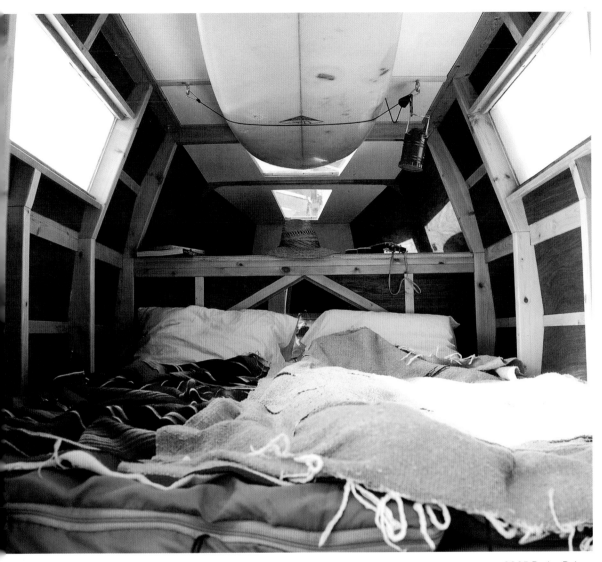

2005 Dodge Dakota
Pescadero, California
Contributed by Schuyler Robertson

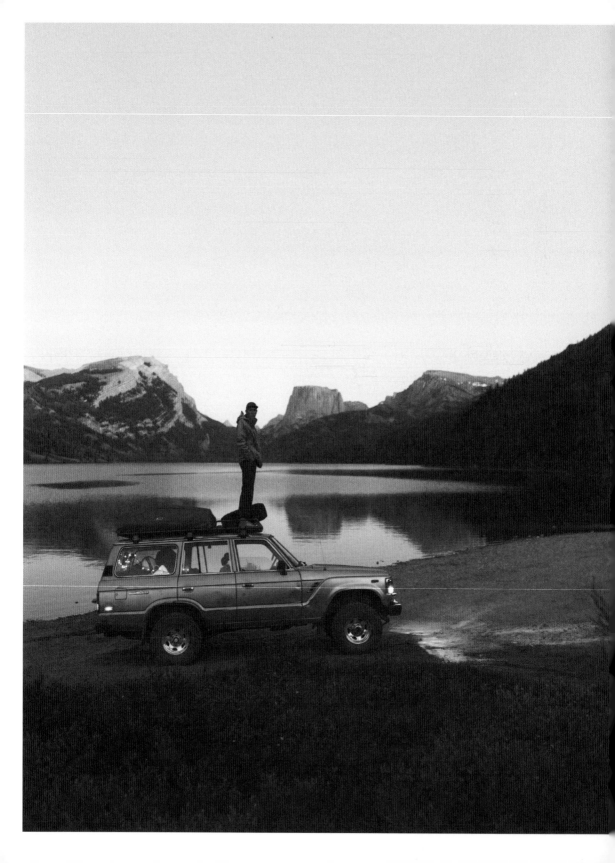

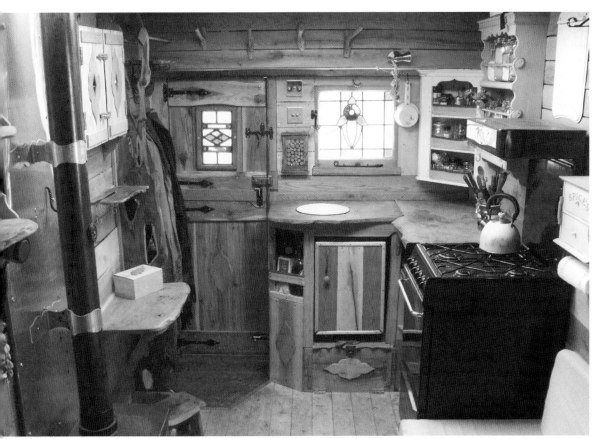

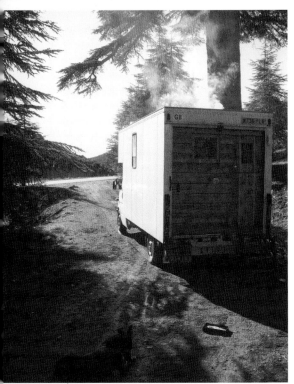

Above and left:
2000 Mercedes Sprinter Luton (HMS Hail Stone)
Morocco and Portugal
Contributed by Bill Goddard

Opposite:
1984 Toyota FJ60 Land Cruiser (Burt)
Wyoming
Contributed by Forrest Mankins

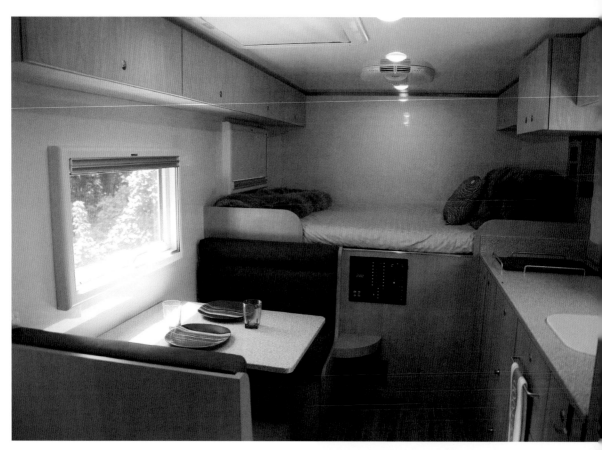

2001 6x6 M1083 US Military Tactical Vehicle
Above and opposite: Galena, Missouri
Contributed by Rene van Pelt

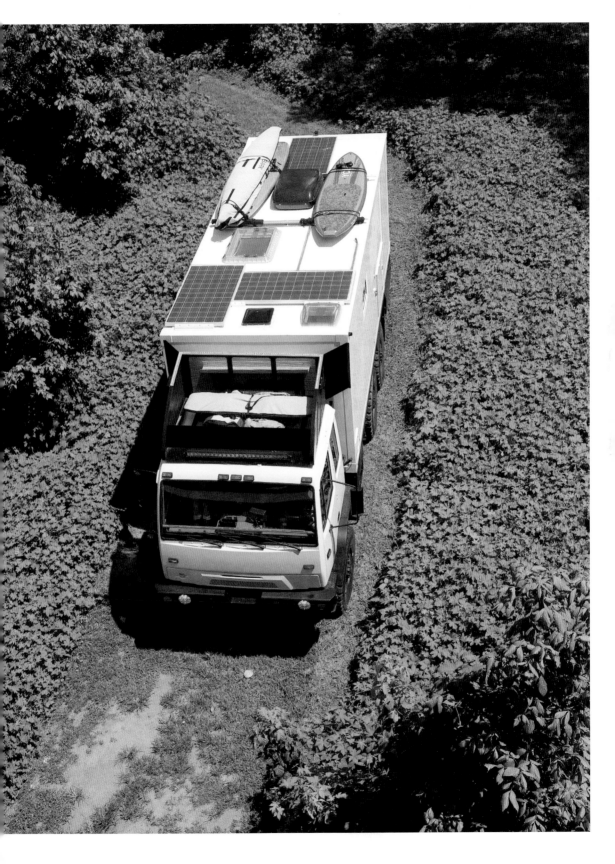

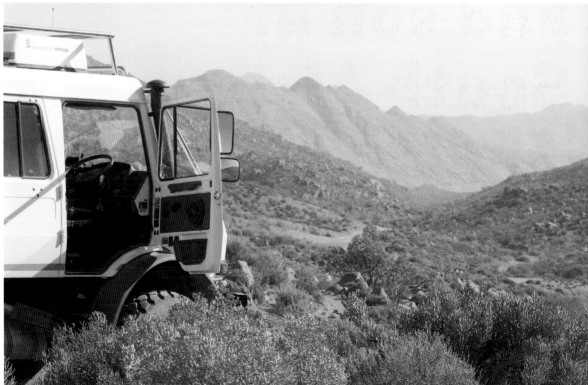

Top: Cape Town, South Africa; *bottom:* West Coast, South Africa

Large and in charge: A top-notch Unimog camper project connects father and son in South Africa.

A few years ago, I spent a fair amount of time in Europe. As an American, I always thought that an RV was something your grandparents rented and drove down to Florida or Texas to escape the cold winters in the Midwest, but RVs are different overseas. I drooled over the myriad custom campers that we don't have access to over here in North America. At the top of the list of rigs I lusted over were the large 4x4 campers built out on a Mercedes-Benz Unimog format. They could go anywhere in any weather, and had the comforts of a small apartment in their cabin. Back in the States, I'll occasionally catch sight of one of these campers—presumably in the middle of some transcontinental journey—and my interest is piqued again. South African Svend Rands and his father built a camper on a 2012 Unimog and he was good enough to answer my questions about these all-terrain beasts.

FOSTER: What's the make and model of your camper?

SVEND: A 2012 Mercedes-Benz Unimog U 4000

FOSTER: Why a Unimog? Did you consider any other large 4x4 vehicles?

SVEND: I grew up around Toyota Land Cruisers. We have had all kinds, from pickup-type trucks to SUVs. All of them were fitted out to explore Africa. The Unimog seemed to be the obvious choice when looking for something bigger. It has some serious 4x4 capabilities, and with the extra space it's extremely comfortable. Once you've been for a ride in a Unimog, I think it would be pretty hard to consider anything else.

FOSTER: How did you find it, and what's the story behind it? From what I gather, Unimogs often have interesting pasts.

SVEND: That's probably because they last forever. I still see plenty of old Unimogs being used for daily work. I often see them as fire trucks or drilling rigs. It seems like they never die. The new models had just been released in South Africa when we saw one for the first time. I think we had bought one within that week, and that was when all the fun started.

FOSTER: How did you modify it?

SVEND: When you buy a Mog new, all you get is a truck with a bare, exposed frame in the back. It's completely up to you to do what you want with it. It took us a while to find the right guys to work on the truck and help us build our dream. A company called Alu-Cab in Cape Town helped us with the build. These guys did such a great job. She was the first of her kind, so you can imagine the engineering and design that went into it.

Overall, we tried to keep everything as simple as possible. The last thing you want when you are on a remote trip is equipment failure. That being said, we have a pretty amazing electrical system that was designed by engineers who usually outfit yachts. I think we found a really good balance that

West Coast, South Africa

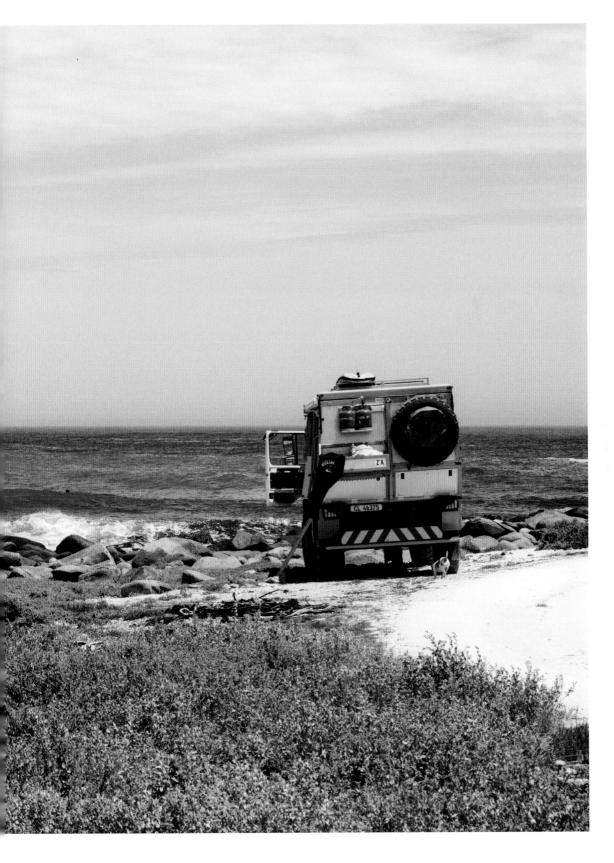

allows us to run fridges, freezers, lights, and water pumps as well as any other electrical use we might have. All of this is powered by big solar panels on the roof that keep our batteries charged. At Afrika Burn [Burning Man in Africa] I'm able to run everything off the truck, including extra lighting and a sound rig. I usually keep this going for about seven days on solar power. I don't ever have to start the truck. Just a bit of sun and she's good to go.

We also have plenty of water on board, so taking a hot shower isn't an issue either. There's a kitchen inside, but we generally do most of our cooking outside of the truck were we have a gas cooker and running water. Also, it's Africa, so we can always cook on the fire!

FOSTER: How did you build the sleeping setup? And how many people can you travel with?

You don't feel like you're in a tent, you feel like you're in a little home.

SVEND: The entire back living quarters is built out of aluminum and is super strong. We can travel with five people really comfortably. Three people can sleep in the roof tent and two in the tent that flops down on the side. There is, however, space for six if we really want to squeeze in.

FOSTER: Where have you taken it?

SVEND: This truck was my dad's baby. We built it together, but he has enjoyed most of the longer trips in it. He's traveled through South Africa, Namibia, Botswana, Zimbabwe, and Mozambique pretty extensively. Unfortunately, he passed away last year and we never got to do a proper trip together. I've done a couple of surf trips up the west coast of South Africa and I'm busy planning a trip to Botswana in June.

FOSTER: Have you met other people with Mogs on the road?

SVEND: You don't bump into them all the time, but when you do there always seems to be a connection and appreciation of one another's rig. Each Mog is unique and it's always great to see how people customize theirs to suit their needs. If you drive one you are definitely one of the family.

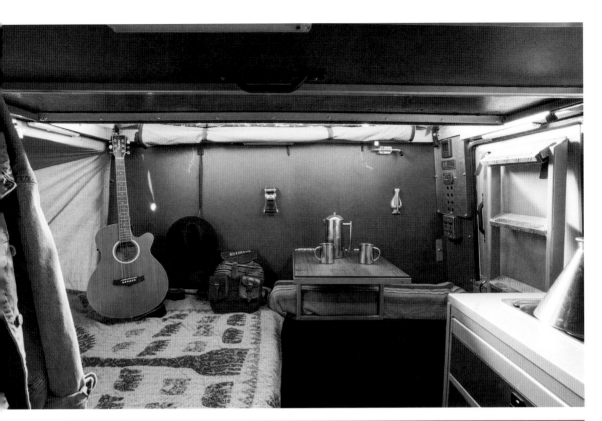

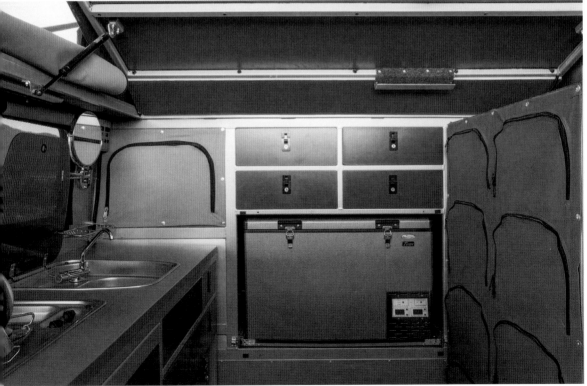

Cape Town, South Africa

FOSTER: Have you had any breakdowns?

SVEND: We haven't had any breakdowns yet. These trucks are built so well that they seem indestructible. My dad and his mates once had a flat tire and spent most of a day trying to change it. As you can imagine, it's pretty difficult to lift a 150-kilogram (330.6-pound) tire.

FOSTER: What would you recommend to someone building a large camper? And what would you change about yours if you could?

SVEND: Start with a good vehicle. Think carefully about how you plan to use it and design accordingly. Install the best electrical system possible without overcomplicating things. I don't think I would want to change much at this point. We recently took the toilet out. I hate those things. I guess each time you do a trip you get new ideas. For now, I'm happy with her just the way she is.

FOSTER: Is there a place you've been dying to go in your Unimog? Tell me about your upcoming trip to Botswana.

SVEND: It's really hard to pick a single destination. Often, a big trip would include a couple of countries. I have really been wanting to visit Gonarezhou National Park in Zimbabwe. It's apparently still really wild, and you can go a few days without seeing any other people.

There are a couple of us doing a trip to Botswana later this year. I have been to many of the spots before, but cannot wait to go back. First, we will be going to the Kgalagadi Transfrontier Park. It's a wildlife reserve in the Kalahari Desert region of Botswana and South Africa, bordering Namibia to the west. Imagine beautiful red dunes, dry riverbeds, and lions visiting you in your camp at night. This place is really special to me, as my dad often took us there as kids. It's still wild and untouched. From there we will be heading to Moremi Game Reserve, which is situated on the eastern side of the Okavango Delta, and then on to the Makgadikgadi Pans National Park. This is one of the largest salt flats in the world. Traveling to these places one always has to be pretty self-reliant, and that's where the Unimog truly comes into its own.

CONTRIBUTORS

Stephanie Jewel Artuso

James Barkman

Cyrus Bay Sutton

Sarah Bergland

Martina Bisaz

Ian Boll

Joanna Boukhabza

Eric Bournot

Marianne Brown

David Browning

Taylor Bucher

Jennifer Callahan

Jace Carmichael

Camille Casado

Sean Collier

Capucine Couty

Callum Creasy

Hayato Doi

Tim Eddy

Lara Edington

Tommy Erst

Tiphaine Euvrard

Hannah Fuller

Mark Galloway

Christine Gilbert

Bill Goddard

Ian Harris

Clifton Hart

Alex Herbig

Jens Hruschka

Garrett Hystek

Brook James

Stijn Jensen

Isaac Johnston

Jonathan Edward Johnston

Gabriela Jones

Daniel Kalinowski

Peter Kappen

Charles M. Kern

Grant Koontz

Greg Laudenslager

Austin LeMoine

Brett Lewis

Jennifer Lorton

Ryan Lovelace

Forrest Mankins

Randy Martin

Megan Matthers

Ben Matthews

Callie McMullin

Mali Mish

Kathleen Morton

Jay Nelson

Amy Nicholson

Ross Nicol

Zachery Nigel

Florian Obsteld

Bec O'Rourke

Jessica Perez

Mike Pham

John Power

Svend Rands

Frankie Ratford

Road for Greta

Schuyler Robertson

Sergio Garcia Rodriguez

Norm Ruth

Jane Salee

Blakeney Sanford

Joel Schroeder

Mary Schroeder

Sarissa Sevincgil

Ben Shumlin

Casey Siers

Evan Skoczenski

Adam Smith

Logan Smith

Michael Stevens

J. R. Switchgrass

Sean Talkington

Freddy Thomas

Peter Thuli

Beau van der Werf

Rene van Pelt

Julia Vasilevskaya

Dillon Vought

Emma Walker

David Waugh

Grace Wexler

Gunnar Widowski

Thomas Woodson

ACKNOWLEDGMENTS

I would like to thank Al James for editing and compiling the interviews in this book, and Randy Martin for wrangling and editing the hundreds of photo submissions. This book would never have happened without the energy and efforts of the contributors from around the world. Their passion and amazing photos made this book possible. Thanks to my friends and family for being constants in my ever-changing life and for telling me to go for it when I left my life in New York and hit the road.

ABOUT THE AUTHOR

Foster Huntington is a photographer and filmmaker from Skamania, Washington. In 2011, he left his fashion job in New York City and moved into a camper van. For the next three years he traveled around North America, driving some 120,000 miles, surfing and camping. He began the popular Tumblr account and hashtag van-life.net and self-published a book, *Home Is Where You Park It*, with photos from his time on the road. He now lives in a treehouse in the Columbia River Gorge in Washington and works on short films and photo projects in his studio.